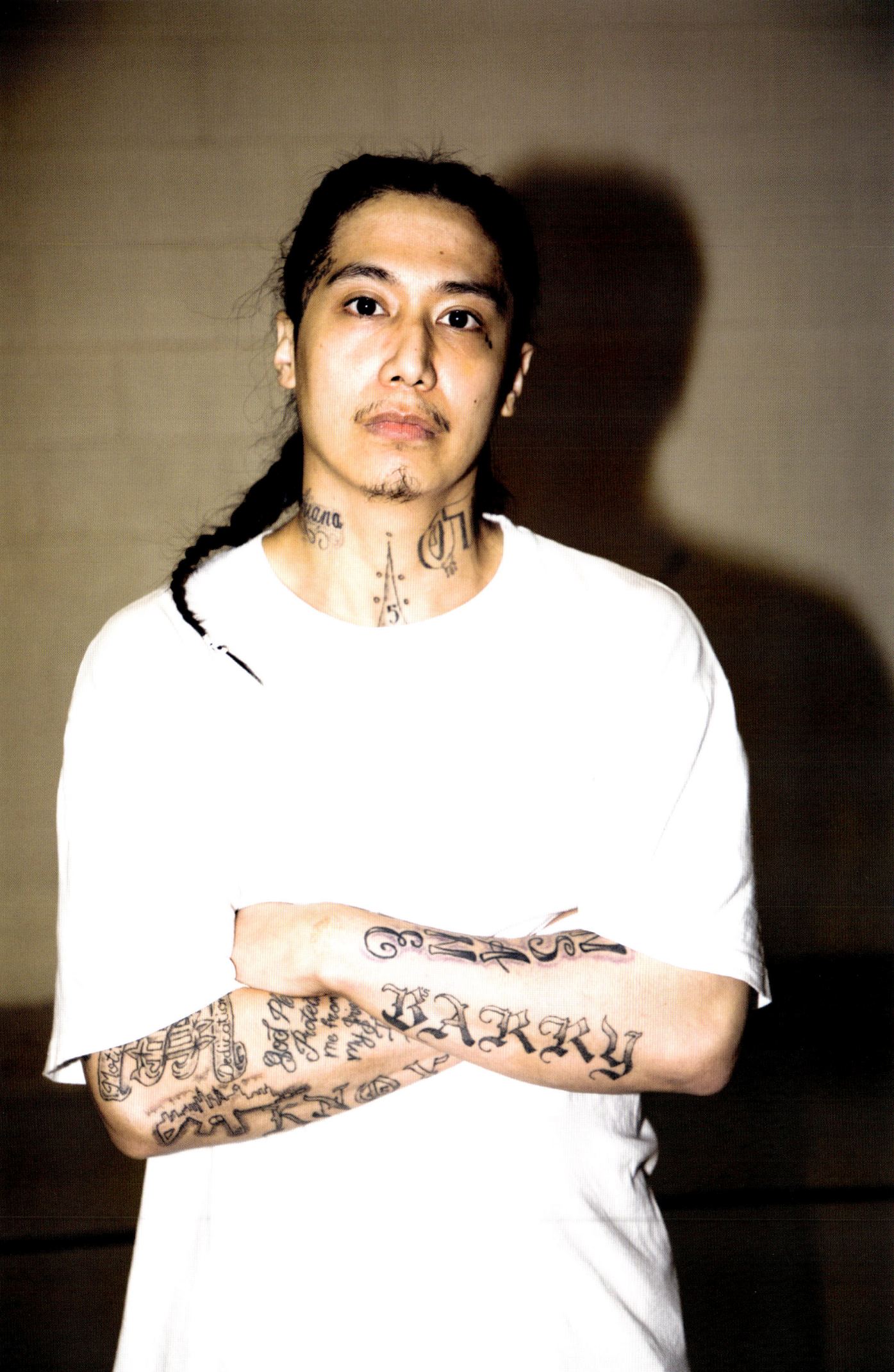

Brooklyn, NY

I REFUSE FOR THE DEVIL TO TAKE MY SOUL

INSIDE COOK COUNTY JAIL

LILI KOBIELSKI

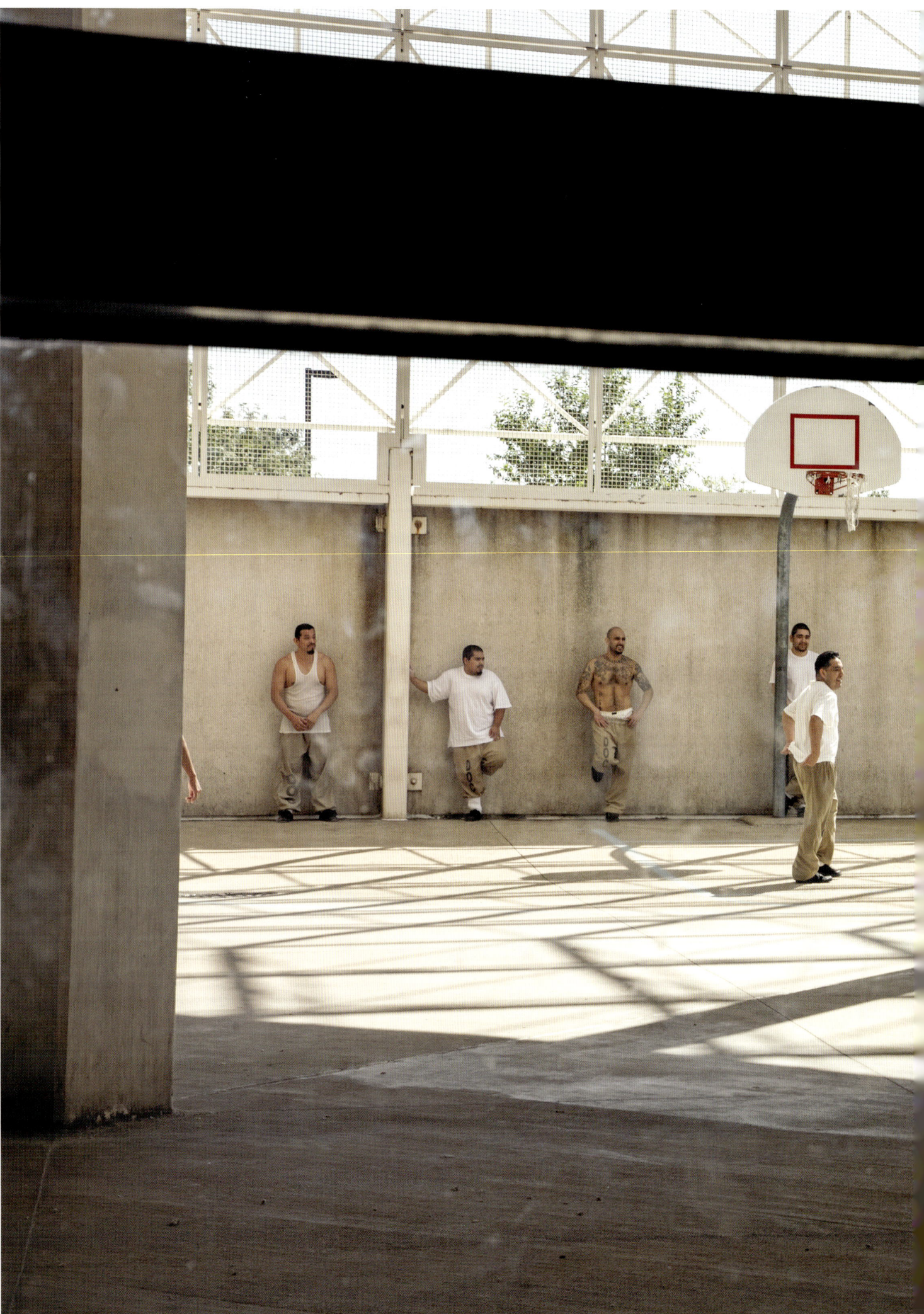

INTRODUCTION

Mary Crowley

vice president for communications
and public affairs,
Vera Institute of Justice

"Nothing about us without us," is a common refrain in justice reform advocacy circles, just as it has been for AIDS activists, disability rights groups, and others. To fundamentally alter our bloated criminal justice system—which disproportionately targets people of color, those living with mental illness, and the poor—we need a very different set of policy options. But the charge for change is not going to come from policy players, or at least not only them. The beating heart of this work—what animates it, what makes people sit up and pay attention and demand more of their government actors—is the lived experience and voices of those who have been impacted by these policies, of the people in our jails and prisons, and their loved ones outside and often too far away from them.

For 57 years, the Vera Institute of Justice, where I work, has driven change in the criminal justice system through research that details problems and implements and brings to scale innovative solutions. We're currently working to keep people out of jail in the first place with bail reform; to make life for those behind bars better by making solitary confinement a rare and short-term practice, and by creating restorative justice systems and college programs within prison walls; and to make sure that people are welcomed back home when released by opening the doors to public housing. We do this by partnering with those who pull the policy levers—the judges, the wardens, the district attorneys, the mayors, the governors.

We do it because we believe that our justice system must be organized around an inherent respect for the dignity of every person. The stories of how our justice system impedes that dignity are what motivate reform. And those stories are what we see in Lili Holzer-Glier's elegant and eloquent work. In her photography, and in the relationships she builds with the people who share their stories, we see the dignity of people too often removed from society's view.

At Vera, we got to know Lili when she worked with us on a powerful series of photos from Cook County Jail in Chicago for our Human Toll of Jail project. For that project, which is part of the Safety and Justice Challenge, an initiative to change the way America thinks about and uses jails that is funded by the John D. and Catherine T. MacArthur Foundation, Lili spoke to and photographed people living and working in a jail that is one of the largest in the world. More than a third of the nearly 9,000 people living there have mental health challenges, which is why Cook County Jail is known as one of the largest—if not the largest—mental health providers in the United States.

In this volume, Lili continues the work she began with Vera with an expanded series of photographic portraits and interviews. As with all portraits, they force us to look deeply at the subject. In this volume, many are people who have endured terrible trauma and psychic and physical pain, and we have chosen to warehouse them. Yet, their dignity shines through despite their circumstances. Similarly, we see the dignity of the social workers and psychologists who try to help in an environment not designed for healing. Look into the eyes of the people Lili brings to us; listen to what they tell us. This is not what justice in America should look like. This is what we need to change.

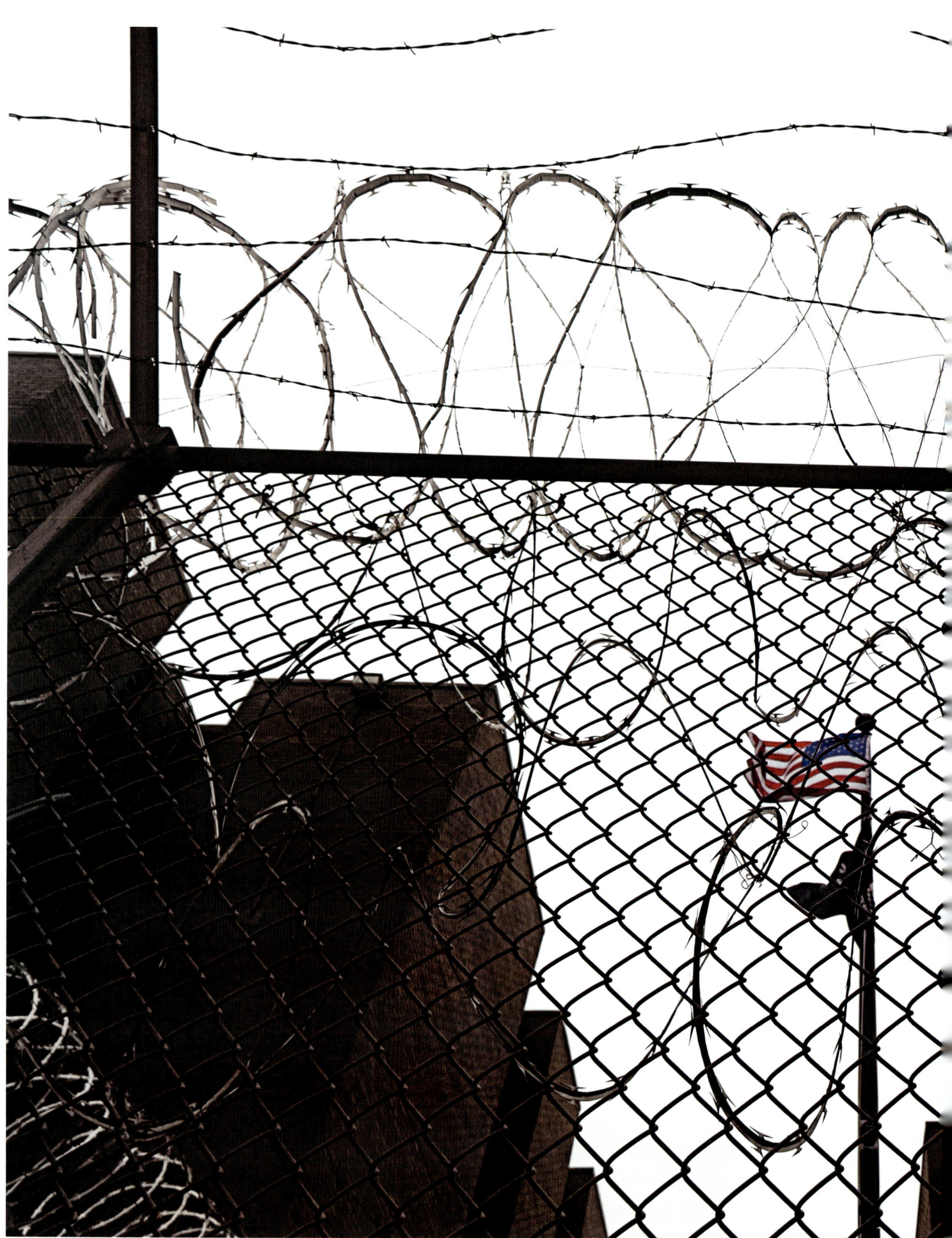

FOREWORD

Lili Kobielski

In late 2015, I began taking portraits of inmates at the Cook County Jail in Chicago. Working in collaboration with Narratively and the Vera Institute of Justice, with support from the John D. and Catherine T. MacArthur Foundation's Safety and Justice Challenge, I began documenting the prevalence of mental illness among inmates at Cook County Jail in an effort to humanize the reality of mass incarceration in this country.

The Cook County Department of Corrections is one of the largest single-site pre-detention facilities in the world, with an average daily population hovering around 8,000 inmates. It is estimated that 35 percent of this population is mentally ill.

According to a May 2015 report by the National Alliance on Mental Illness, Illinois cut $113.7 million in funding for mental health services between 2009 and 2012. As a result, two state-operated inpatient facilities and six City of Chicago mental health clinics have shut down since 2009. Emergency room visits for patients having a psychiatric crisis increased by 19 percent from 2009 to 2012, and a 2013 report by Thresholds found that the increase in ER visits and hospitalizations resulting from the budget cuts cost Illinois $131 million—almost $18 million more than the original "savings."

In addition, Illinois Governor Bruce Rauner's refusal to pass a budget for more than two years has caused more than 80,000 people in Illinois to lose access to mental health care. Two-thirds of nonprofit mental health care agencies in Illinois have reduced or eliminated programs, and a third of Chicago's mental health organizations have had to reduce the number of people they serve.

In 2011, the Cook County Sheriff's Office estimated that it costs $143 per day to house a general population inmate. But when taking into account the treatment, medication, and security required to incarcerate a mentally ill person, the daily cost doubles or even triples—yet now more patients than ever are being treated in jail rather than at a mental health facility. Cook County Jail has become one of the largest—if not the largest—mental health care providers in the country.

As I continued to work on this story beginning in early 2016, I decided I wanted to expand the project into a book. Each portrait within is collaborative—I asked "How would you like to be photographed?" and then we worked on making the portrait together. I chose to transcribe our interviews exactly as they were spoken, as I believe that these are voices that must be heard.

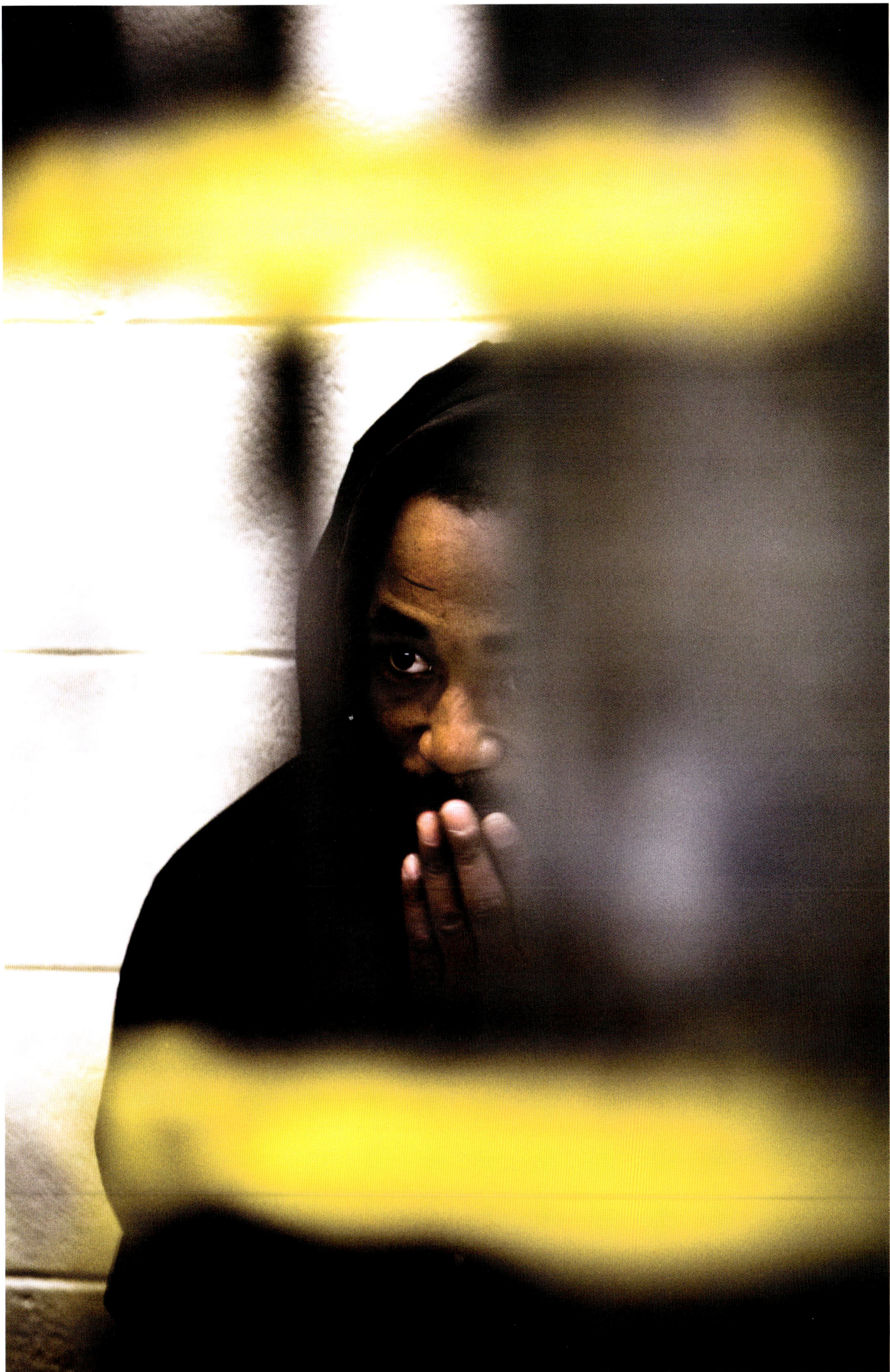

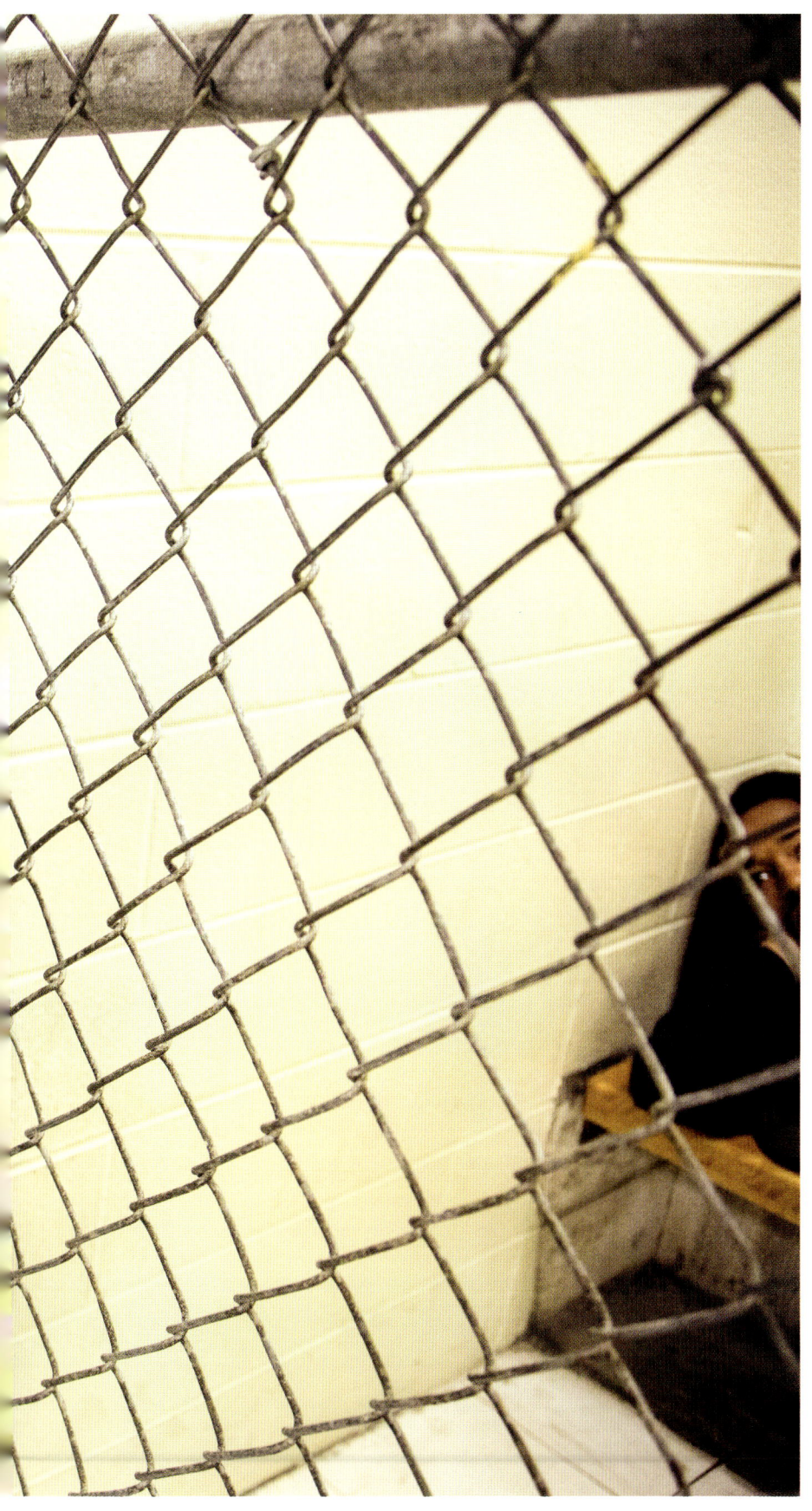

Elli Petacque Montgomery,
social worker, director of mental health policy and advocacy, Cook County Jail

It was no surprise that when they closed the major hospitals in Illinois—and folks didn't have insurance—that they would end up in here.

The more they closed the hospitals, the more they closed the community mental health agencies, the more that people became uninsured—and they lost the case manager in their life. The person to link up, [to tell them] "Here's what you need to do to get your medication, here's the bus you need to be on." Once they cut out constant case management, these people really didn't have a link to get help, and a lot of them lost their housing when they were acutely psychotic and needed to be hospitalized. There were no hospitals to go to, so we ended up with a lot of homeless people in Chicago, mentally ill on the street.

Those people would then, just like anyone else, be hungry and cold, and you would see what we call crimes of survival—people that would show up at the 7-Eleven, they're thirsty, and they're drinking, and there's a village of voices in their head. They're disoriented, they don't know where they are, and the police are called, they're brought in here.

By the time they get to us, they've been off their medicine so long, they're disoriented—they absolutely don't know where they are. They think they're waiting for the army, or the delusions are so severe they think someone has literally cut their toes off. Our job here is to do our best to advocate on the behalf of those people suffering from mental illness, catch them early and give them resources first thing before bond court and also when they're in jail.

Our goal is to try to convince people to get help and at least to give them choices—give them emergency numbers to call, to give them a plan to think about, and let them know that until they tackle and get help with their mental illness and their substance abuse, they're going to keep coming back over and over and over again. Our main objective is to try to stop that cycle and to get them help with the limited resources that are in Chicago right now.

People that historically would have gone to public hospitals or state hospitals are ending up here. We are the de facto mental health hospital now. It is far more expensive to try to manage mental illness and handle incarceration at the same time. It's also counter-therapeutic: to have someone in a cell and then try to do therapy in a jail that holds anywhere from 8,000 to 10,000 people is incredibly challenging.

Some people might need to address post-traumatic stress disorder or their anxiety, their depression, their substance abuse—they're not going to get that in a jail setting. It's just not going to happen.

Someone I talked to today said to me, "I just can't afford the meds, they're too expensive." You hear that over and over and over. I look at someone suffering from severe mental illness as someone who has cancer. If we were to say these are all people with cancer, the country would have handled this differently. It wouldn't be an issue. There would be much more care and concern, and unfortunately, the stigma is still out there.

Sometimes, I have people that beg me to stay here. I have a female I just interviewed who begged me not to let her out of this jail. She's severely bipolar, she will use heroin—which she has been doing for eight years—to deal with her illness. She hasn't told anyone. She was diagnosed when she was 18, and she's literally not told her family. If we could keep her in here she would stay, so she could get her meds, not do heroin, and get treatment.

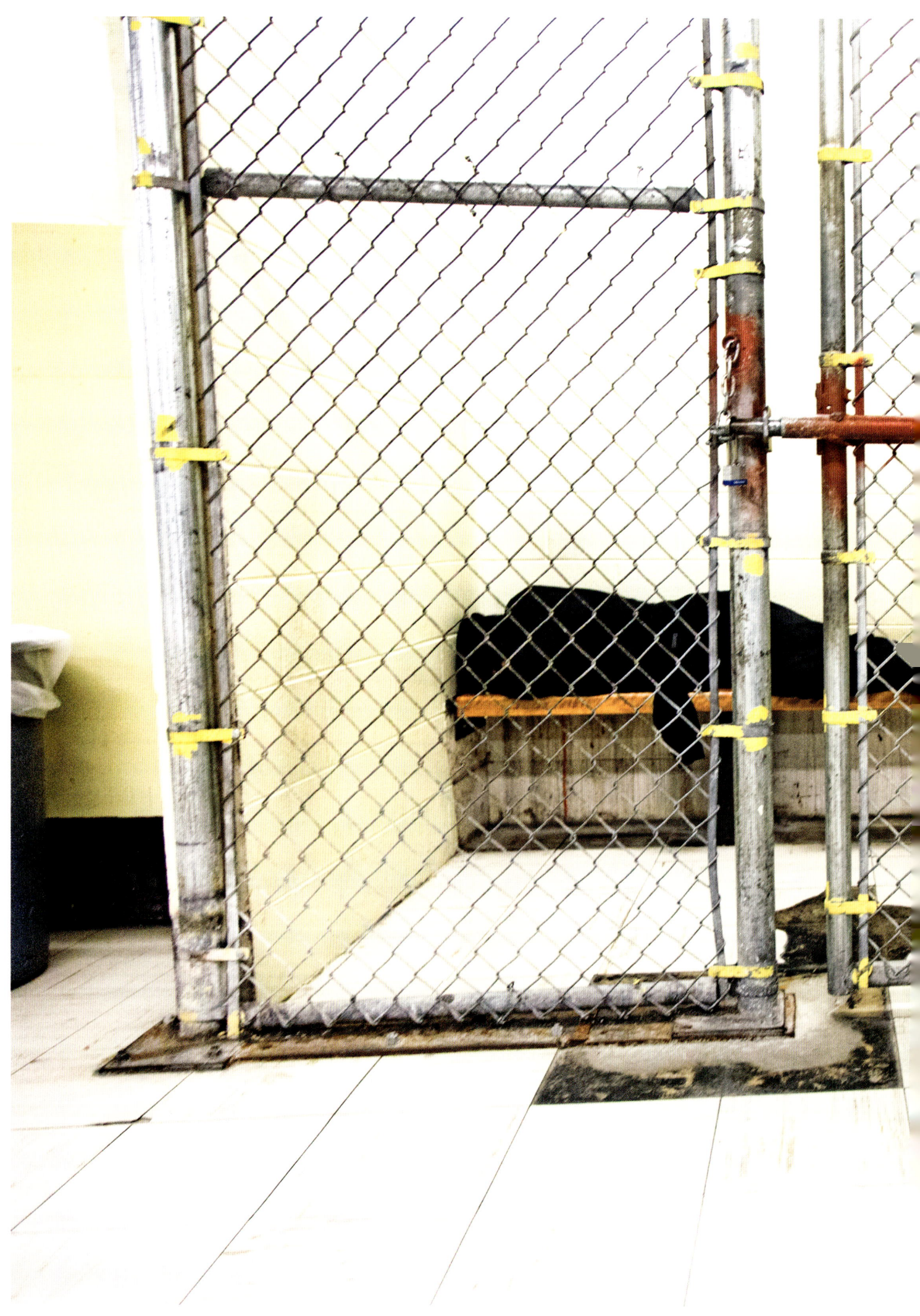

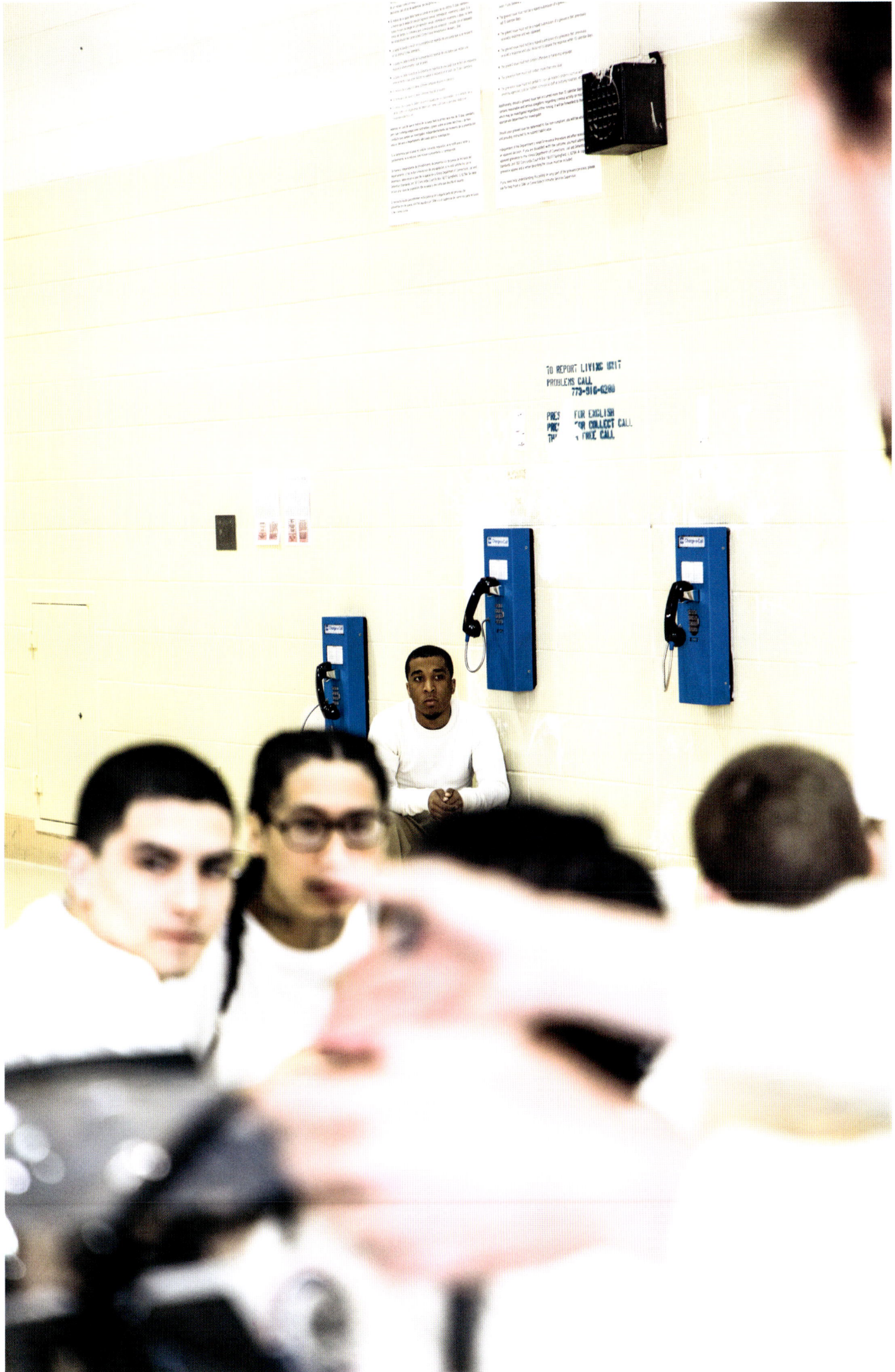

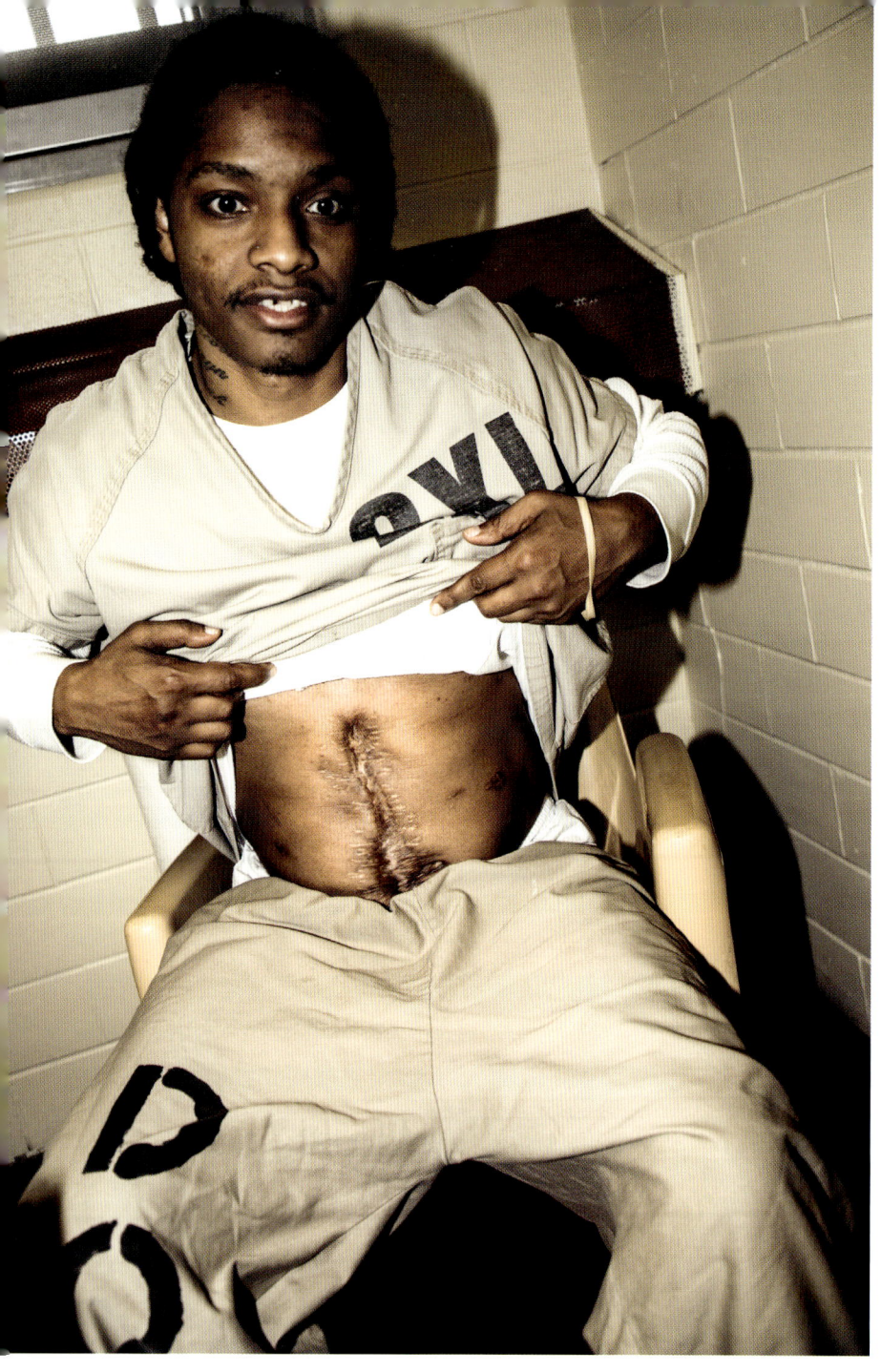

Eddie

I'm from the East Side of Chicago. Born and raised. Never been out of the city. My mother's a nurse, my sister's a nurse, my brother's a nurse, my other sister do home care. I'm the one who made bad decisions in life.

My dad was dead my whole life so I never met him. I was one, so I don't remember how he looks or nothing. My mom had six kids when I was growing up so it was rough on us, she was a single parent. When I turned 14, I started doing things to try and help my mom and take care of myself, so I was out on the streets selling drugs since I was the age of 14.

Then I had my first son—she was pregnant when I was 15 but he was born when I was 16. So I had my first son when I was 16. I'm 34 years old now. My son's going to be 18 next month and he graduated high school. It's just a blessing that he ain't following in my footsteps and going through what I had to go through in life. I've been in jail at least 16 times. Drug cases, selling drugs. They got me for a pistol case this time. I've been here for two years. Still waiting for trial. Waiting. I put in a motion to suppress evidence and they've been prolonging my motion for a whole year. It just seems like they're prolonging me so I have to end up taking some time. I might have time in next time I go to court. I might end up copping out. I'm eligible to get bail but I can't afford it. It's $100,000.

I got shot, too. I got shot 15 times back in 2010. That's the reason I carried a gun, for self-protection. Some people carry to do bad things, but that's not the

reason I had it. I almost died. I stayed in the hospital for two months, then I had to stay in the house for two more months. Why? Just being in the streets, hanging with the wrong crowd, gangbanging at a young age. I was in a gang since I was 14 years old. That's when I started selling drugs. I've been in a gang a long time. I'm ready to do something different. I'm tired. This is the longest I've had to sit in jail. Coming back in and out of here, sometimes I think it just be God. I know it's me making bad decisions but sometimes it just be God to me, taking me off the streets for way bigger reasons than I can imagine. I think he's saved me sometimes.

The cycle is over with. That's why I'm blessed. I'm happy I was arrested and go through the program; the Mental Health Transition Center here, it's helped me change my thinking and behaviors, and sometimes you got to change the people you're associating with. I'm actually ready to get it together this time. I won't come back. I got a lot going on at home. My son, he graduated high school. He doing good. I want to see them grow up, so I'm going to do whatever I got to do to make that happen. I'm going to change, do what I got to do. I'm going to get a job. I got another son, he 14. My older son graduated high school and I was in here, I missed it. I told him we going to make it up, you know? I told him this is the last time in here for me. I'm not coming back anymore. I talk to my kids all the time. I tell them how much I love them and to never forget it.

My sons are by two different women so I try to keep them close. My older son, he's an only child; the baby mama of my younger son has an older child, so I try to keep them close and in the same house. I got two good boys, though. When I was they age I was bad. What led me to the street? Probably my mom being a single parent and me trying to be the man of the house type of thing. I was moving fast at an early age. Early. I was trying to help support my mom, trying to get stuff that I wouldn't be able to get because she has to take care of six kids. The neighborhood, the environment I grew up in as well.

I ain't been gangbanging here. We're in the program wing with none of that going on. We all stick together here in the MHTC. Everybody in here trying for a change. Everybody respect one another, we pray together at dinnertime. Everybody is trying to work on starting their new life when they get back. It's different. You used to come in and they'd ask you what gang you in; ain't none of that going on here. We're looking out for each other. Somebody needs soap, we all gonna pitch in and help that person. It's about sticking together. I was diagnosed before I came in with PTSD. That was from being shot. That was on two different occasions. One time I got shot 13 times, and one time I got shot twice when I was 27 or 28; I got shot twice in the same year. I got shot in my back twice, stomach three times, both knees. One knee four times, the other one twice. I got shot right here, it broke my ankle. They didn't go to jail for it. They had to put rods in my legs. They had to take some of my stomach out. It's called a gastrectomy. They had to take two-thirds of my stomach out because it wouldn't stop bleeding. They say it'll stretch back in time but it will never be normal. But I'm blessed. I got a bullet hole right on my spine. Sometime I think bad stuff happens for a good reason. I wasn't the type to never believe in God, but when that happened to me it made me closer to God. I definitely believe in God, so that's how they didn't kill me—God said it wasn't my time.

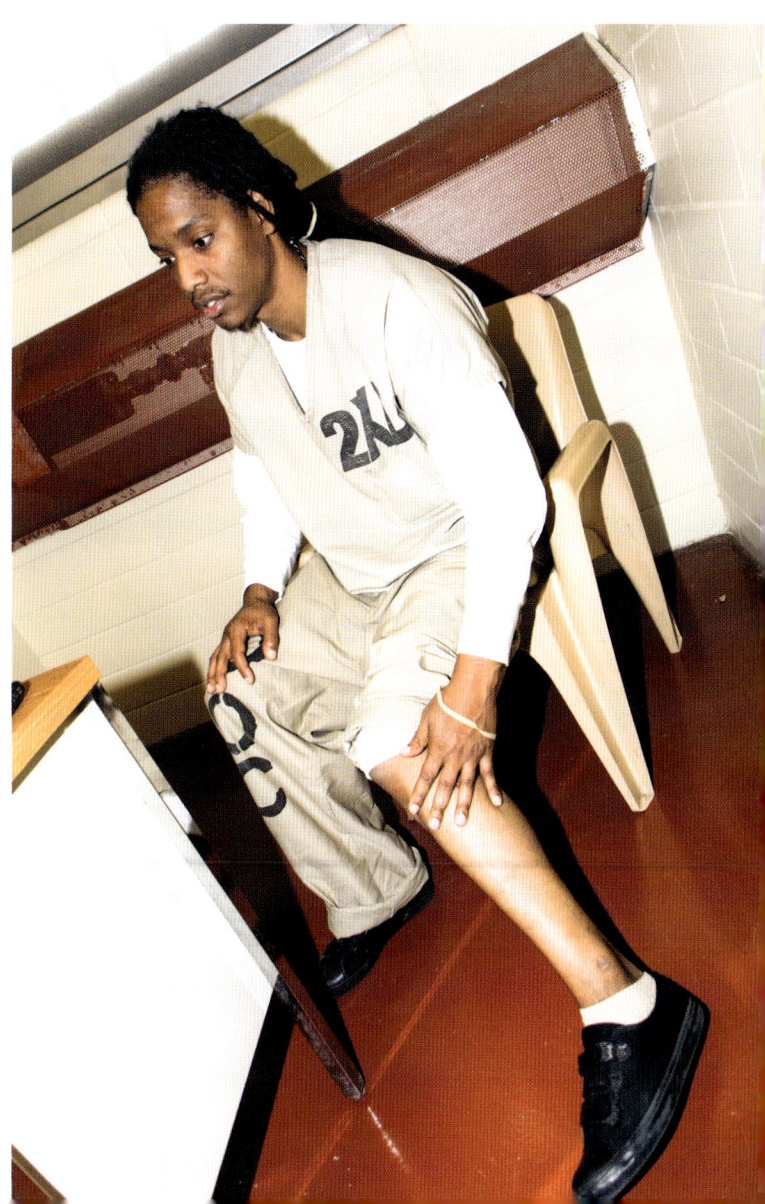

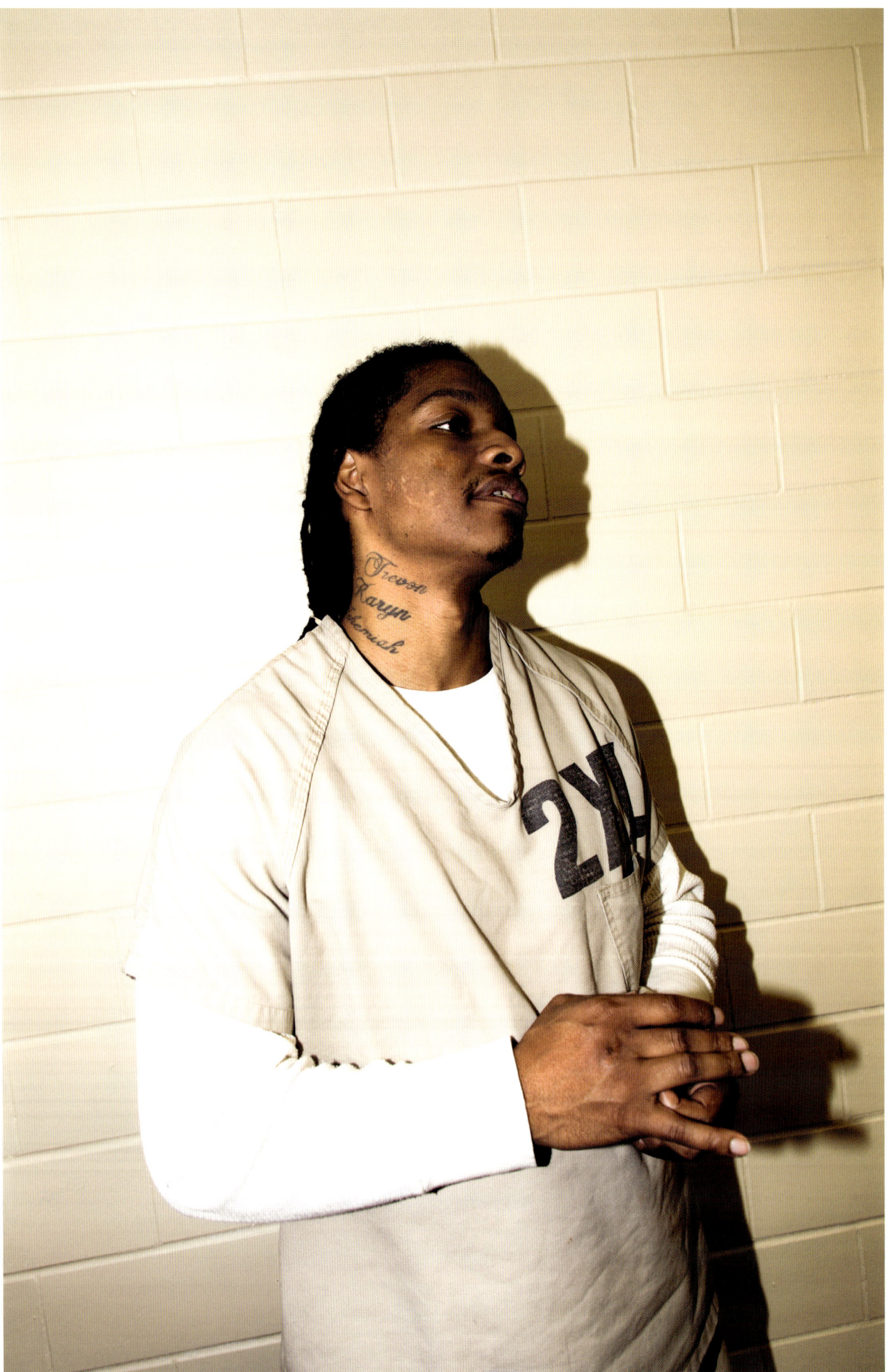

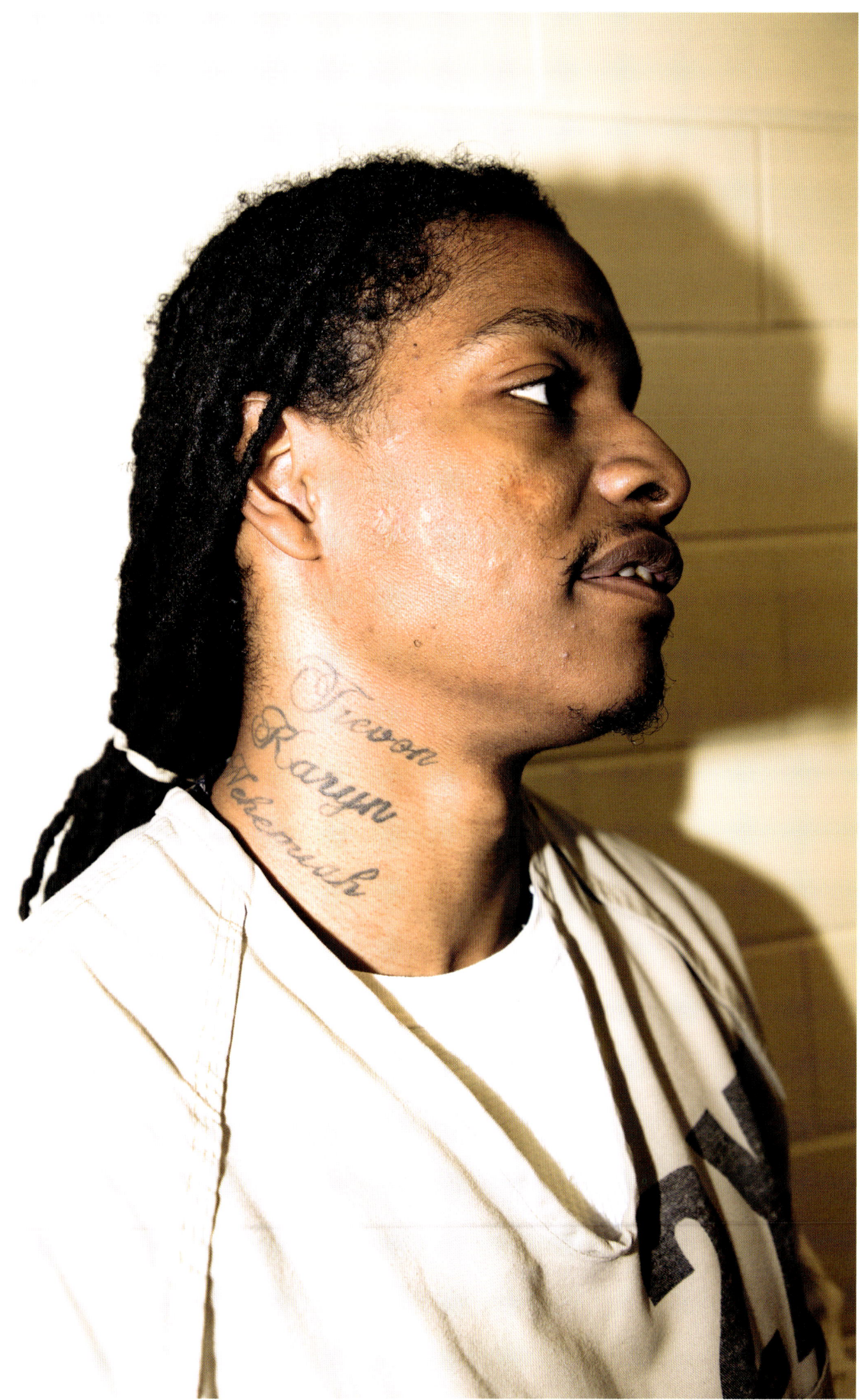

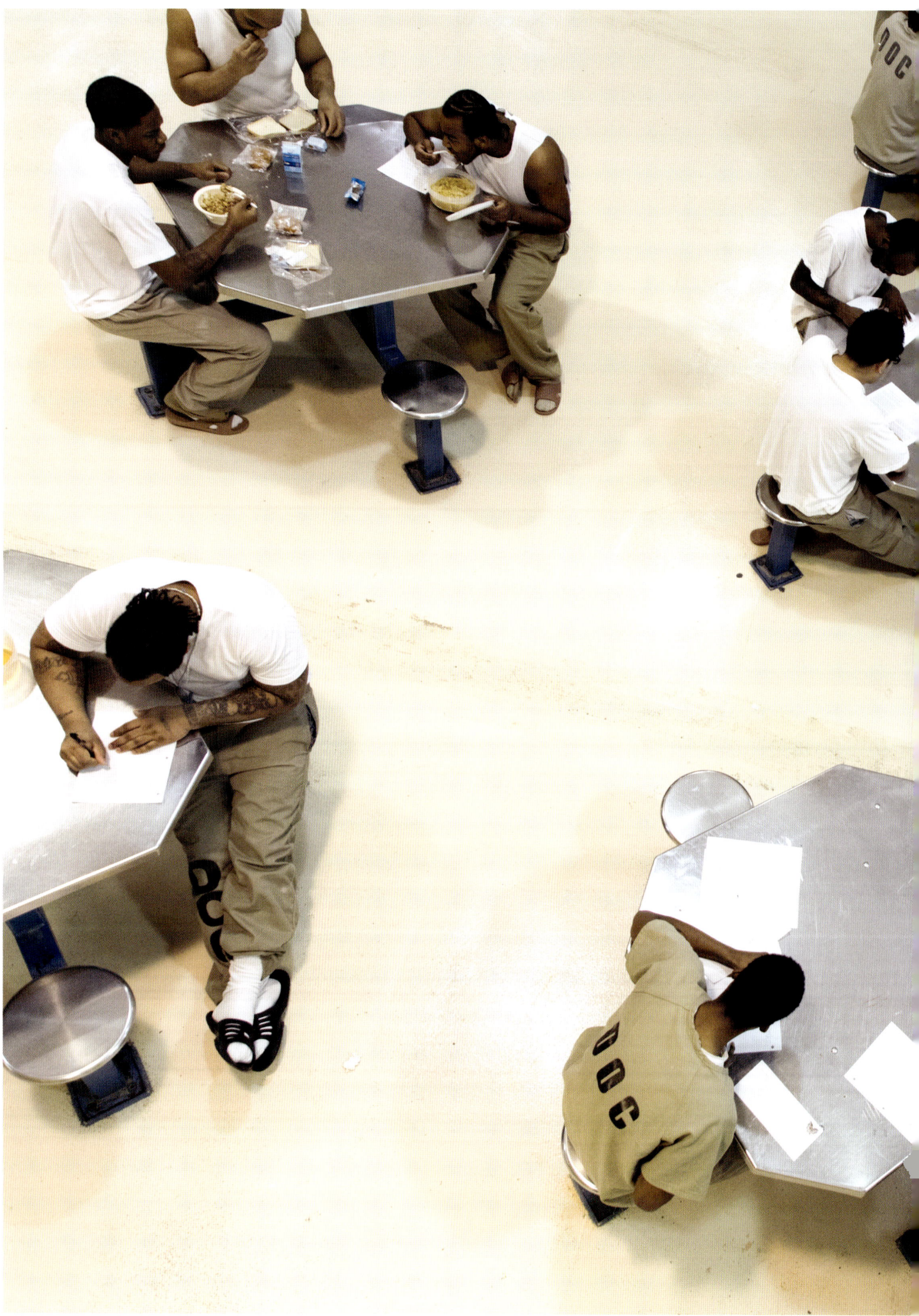

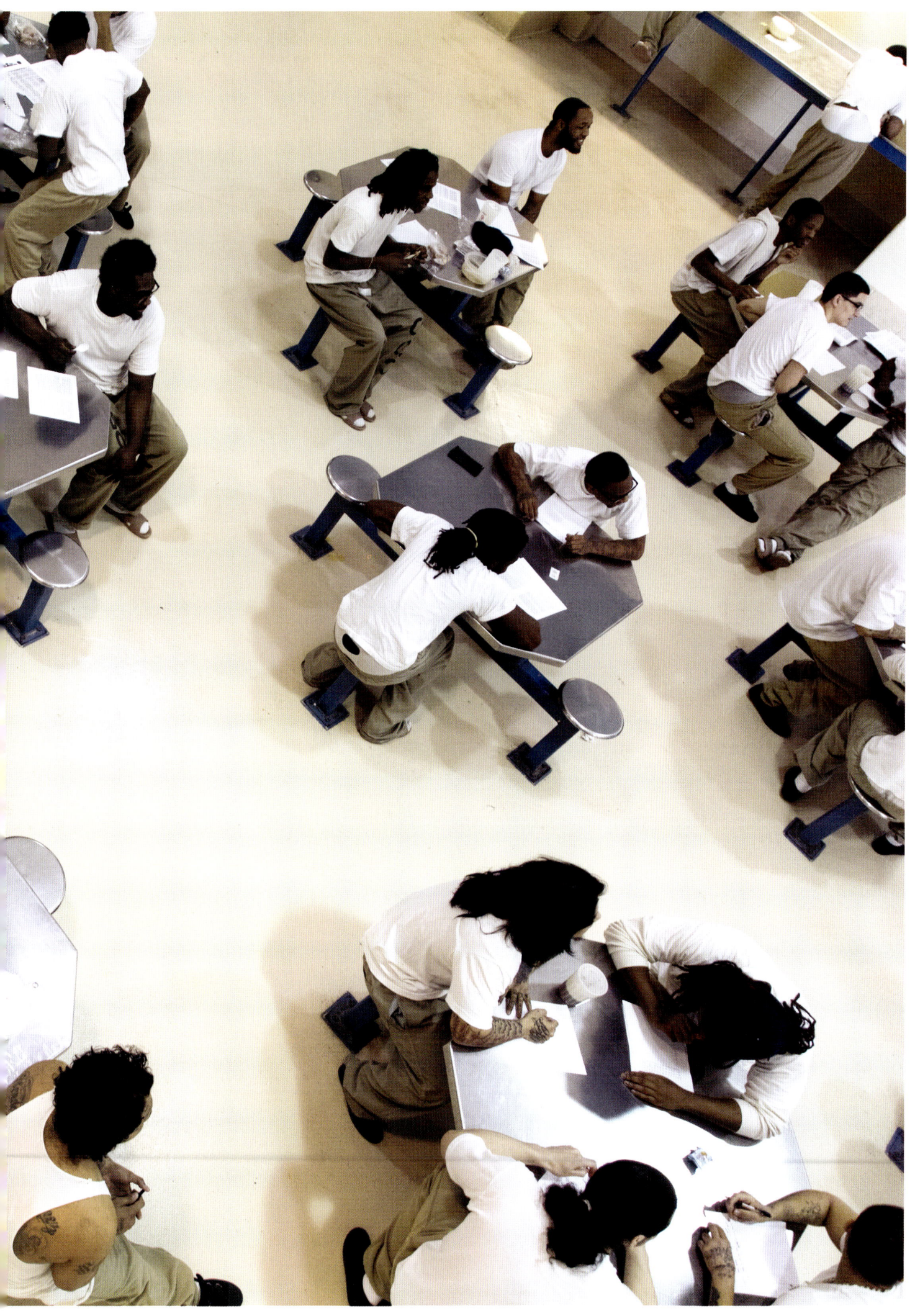

CJ

I'm from Chicago, Illinois. Growing up, my dad was locked up til I was eight years old. When he got out I was happy, but I was also rebelling all the time, getting into fights, getting into trouble. I eventually ended up catching a charge when I was young. I was 13. They put me in foster care, group homes. I was in there til I was about 15 and at 15—my dad, he passed away, he passed away and I was at a group home at the time and they told me they couldn't take me to the funeral because we don't have any transportation, sorry. So I got into trouble then—I ended up in the juvenile department of corrections for about two-and-a-half years, and I got out and now I'm here—I was only out for about a year.

Now I'm here trying to fight for my life. My charges are home invasion, armed robbery, and kidnapping. I just try to stay positive in here, there's nothing really to look forward to but you can't just be here all day sad. You'd go crazy. I'm 18. That year I was out I was doing things I probably shouldn't have been doing. But that's the lifestyle, you know? That's how you grow, that's all you know. And some people try to help you and you don't want to listen and then they see you don't want to listen, and then they stop caring. But really, maybe if they'd tried a little harder you would have listened.

I was given chances when I was younger, in corrections, and I didn't take the chances and now I'm here. I was out there, they let me go, I had just turned 18. I didn't know what to do out there. I didn't even know how to get an ID—no one showed me that. I had to pay rent so I just did whatever I had to do—I'm not referring to my crime.

I got an older brother—he's 21 or 22. I ain't seen him in six or seven years. I don't know what he's doing. I got a half brother—different dads—both his parents passed away. My younger brother, both his parents passed away too—he just turned seven—I ain't seen him in a couple years, either. He's with his side of the family—they're all like, oh, you're a gangbanger, but I just want to see him. I got involved with the gang when I was 11 years old. I didn't know . . . my pops would come and be like, "Look at these guys, **they got nice cars, they got all the females, I wanna be with them!"** I'm just a little kid, so that's what I started doing.

One thing leads to another. First you're fighting people, breaking into cars, and then you start toting guns and then you start selling drugs and you just move up and move up. And I'm in the group homes and they're trying to send me far away—two, three hours away—and I run off from there, trying to come back. I want to come back to my neighborhood. I'm not trying to listen. Hopefully I'll get another chance. I don't want nothing to do with this no more. They're talking about more years than I've been alive to lock me up. It's hard to deal with sometimes. I've only been here nine months awaiting trial, most people been here three, four, five years. So I've got a little while to go. I've got three court dates; I'm fighting three cases.

I'll go into court and they'll tell me come back in three months. My granddad—he don't think he's going to make it until I get out. He's sick, he's telling me he's going to be gone soon—he's all I got left, really. My mom passed away when I was eight. I never knew her—I never met her. When my dad got locked up she ran off. I went to live with my grandparents in Harvey.

Maybe I met her two times when I was young, but I don't remember her. I was with my grandparents until I was eight—when my dad got out of jail. He was in for three bank robberies. I ain't talked to nobody about this for a while . . . I've been feeling like I should. He had a lot of drug problems—he was big when he came out of jail—he was doing good then he got back into drugs. He told me, "If I can't feed my kids one way, I'm going to get it any type of way—if I got to rob banks, if I have to sell drugs I'm going to do it so my kids are going to eat." That's what he taught me. And then he died when I was 15. My dad, he was from the streets, too, you know—as soon as I came home with bruises on me he said, "You done joined the gang, huh?," and he just looked at me like I was stupid and just kept going. I know he cared—he didn't show it a lot—but I know he cared.

I think some of the things that I did were for attention. Eleven years old, I join the gang, I get a tattoo at 12 years old. I got "AOB" across my chest, and he just looked at me like I was stupid—he beat my ass, maybe, but that's about it. We were always poor. Always trying to make ends meet. This program here helps me think straight. I came from Division Nine—over there nobody cares, they do not care. They going to stab you. They do some fucked up shit over there—stabbing people, throwing people over the top rail—they throwing shit at people. You got to turn yourself into an animal. Over here you can relax—not relax, you can't never relax, but you can get into your thoughts. Help yourself think straight. These people that come in—I think some trying to help, some probably don't care—they all speaking a good message, though: you've got to change your thinking, otherwise you going to end up back in here.

There's people who catch murders, beat their murders, and come back in for another murder. Not enough people care—besides our deck, they're not giving plans about what you're supposed to do when you get out. Jail is supposed to rehabilitate you. They're not rehabilitating anybody—they say do your time and get out; they ain't going to give you nothing when you get out, they don't teach you nothing. You're only going to know what you knew. You think you're going to go get a job? It takes a lot of willpower. If you don't have the willpower when you get out, you're not going to make it. It's amazing—they'll throw you in a prison six hours away, and you go right back to the same neighborhood.

I'm getting out of Chicago. This place ain't for nobody. This city will eat you alive. If you're poor—it don't matter what race you are, white, black, Latino, Asian—if you're poor and you live in a poor community, they never care about you. There's shooting everywhere, drugs everywhere, you can't escape it. I have to think about where I want to go. Just not here. I just want to have a regular life. Have a nice little house, some kids. I don't want nothing extravagant—I don't need to be an astronaut, an engineer—just get a nice job and go about my life. Whenever you feel down, don't think you got to go sell drugs, that you got to go rob people, don't think you got to go shoot motherfuckers to fit in. Just keep on going. The answer is to go to school and get out of the community you in. And get yourself out. Don't worry about your friends—don't worry about even your family—you got to take care of them but you got to worry about you. If you focus on everything else you ain't going to succeed. That's all I know.

Janay

I have two girls, two and seven. I had a nice childhood; I graduated from high school. I want to open up my own salon and boutique one day. This is my first time staying a long time here—eight months. I'm here for reckless homicide. Under the influence, alcohol. My first time in trouble was retail theft in 2012 and I got two years' probation for that.

Treatment's been helpful. I'm not like I used to be when I first came in. My behaviors have changed tremendously for the good. I participate more—before I used to be quick to talk, now I'm quick to listen. I used to be quick to anger and slow to think about what happened after I already blew up. This is my first time in recovery. My drugs of choice are alcohol, ecstasy,

pills, and marijuana, but alcohol brought me here. I've learned so much about myself and my addiction. I used to think I was a functional addict but obviously my life has been unmanageable. I started using drugs and alcohol because it was around me. My childhood—I started really young—my dad was an alcoholic and my mom was a pothead. I would say that it's in my genes.

My kids have two different fathers. My oldest, her dad is in here with me, on two different types of cases, though, and my little baby, she's with her father. It's very hard. I'm trying not to get used to it for long because I know I'm going home one day, just not as soon as everybody else is.

Being here is trauma. This right here is a lifelong lesson. Today we "wrote a letter to our addiction," and my letter was to alcohol. It was like a breakup letter to alcohol. I said, "I'm taking my life back and you will no longer have the power over me. I can't believe I allowed you to treat me this way. I thought you loved me the way I loved you."

After my boyfriend went to jail in November and left me with all the bills, that's when I started drinking really heavily. I went out drinking and blacked out, a car accident; I didn't cause it but people lost their lives. I'm the only one that made it out alive. Every day I wake up and I'm like damn, I'm really in jail. It's just crazy that alcohol is legal and it has so many effects on people. I'm going to take this time here to work on myself and to get all I can out of these groups and this treatment because when I get back out there, it's going to be really hard to go back to the people, places, and things. I need to change my scenery, to change me, period.

Whenever I have free time I want to drink. When I was at work on a break I would drink. I drink alcohol to escape from reality, to escape whatever was bothering me or stressing me out. I would drink to ease my mind, to just forget about it. And once the drunkness is gone the sadness comes back, and I need one more, another bottle. My situation isn't as bad as other people's but this is my rock bottom. I have never been this low ever in my life. Ever. I lost everything besides my life. I never want to go back to using any type of drugs. So hopefully these wonderful people here can help me get a nice job to keep me busy.

I thank God because I think He bring me here for a reason. I had other blackouts where I made it home safely but I think I'm here for all the other times I got away with it. He's making me realize, look, I gave you all these passes—now you have to focus and realize that this is not a game, this is your life, and other people's life in your hands. I'm working on it and I think I got it.

Marshun

My childhood was complicated—I was the oldest child out of five. I had to learn what being a protector was. I was always spiritual; I knew I was different, different because there were certain things that would make me cry, hearing people like Dr. King. I started noticing a lot of the people I'm around be down all the time, so I started trying to empower people. My mother, she been dead for a long time; my father, never too much knew him—I seen him once in my whole life. My sisters visit me but my brother don't. He's been in here before so being in here and seeing all that makes him feel bad but he's holding on.

I was charged with aggravated robbery with an indication of a firearm. I was mingling with some guys and someone came up there trying to buy some marijuana and wound up getting robbed and the guys I was talking to took off running. It's all right because it was good for me to come here because I would have never been in this division here. I've been to jail before back and forth. I was 20 years old the first time I came here. It's been complicated at times, dealing with the psych part, but I've come to understand that we've gone undiagnosed, we have emotional disorders we don't know about—it's like a daycare in here sometimes, but I love it here and I champion it.

In the other divisions you're in a cell; in here it's a dorm, there's lots of nice nurses, nice officers. When I first got here I thought these were the nicest people I ever met in my life. I ain't causing no trouble. I feel good. I was diagnosed with bipolarism. Early on, I been trying to fight it without medication which is complicated, but it also made it healthy in a way, to help me understand what I'm going through. A lot of things I should have spoke about when I was young but I held on to. I was diagnosed before I came to jail.

I watched someone get killed when I was seven years old, shot when he was in the swimming pool. I just took off running. And it had an effect on me, paying attention in school—I'd never seen nothing like that. I've been trying to hold up a long time. I was taking medication when I was younger and as I got older, seeing how my behavior was changing, and then my mother was like, "I'm not giving him any medication without knowing the side effects." I take it sometime, sometime I don't take it, then that causes lots of problems.

There's a link between my illness and crimes. Giving up on myself, feeling like I'm not good enough. I just don't understand. I'd have manic episodes where I go and spend all my money. Forgetting stuff, forgetting what I would tell people. But I have to try to stop myself and act positive. I been here for 19 months. Just stay strong, that's what I do. When I get out I'm going to motivational speak. I know that's my calling. I got to take my medication for the rest of my life. Take that, visit the psychiatrist more, keep writing my poems. You get a 30-day supply of medication when you're released from here, then I'll probably just go to the hospital and talk to the psychiatrist there. I want to work on myself, I don't want to hurt no one. I'm a poet and I love the Mental Health Transition Center and I want to thank the people there. It's the first time I was in the program this time and it was luck of the draw. If I had come to this program when I was 20, I wouldn't have come back to jail. But being transformed doesn't come at no certain age. I'm 33 and I feel good. I got a long life ahead of me.

Printiss Jones,
```
Cermak* superintendent
```

We're in the dark here. The people that are in our custody shouldn't be here. The state should be ashamed of themselves and the court should be ashamed of themselves.

No matter how many classes you take, it does not prepare you for what you see here. I've seen detainee patients so agitated, so upset that you can see them struggling within themselves. The veins are popping out of their neck, you start to worry about a medical crisis—a stroke, something of that accord. We know, we've learned that this is not their fault. We know how hard this is. This is heartbreaking; this is heartbreaking stuff. I've seen my officers wipe a tear and try to be strong.

Yesterday, we had a lady that, fully clothed, just went and stood under the shower. Forty-nine years of age. The officers are talking to her, the mental health specialists are talking to her, medical staff is talking to her. We finally get her to come out. She's just soaking wet. So everyone's saying, "Oh, my God, let's get her a blanket, let's talk to her," and nothing is working. All this woman is saying during the whole episode is, "I'm not going to the mall! I'm not going to the mall! You're not making me go to the mall!" We go and get a wheelchair out and put it to the side of her. The staff coaxed her into the chair and she started crying and said, "Why are you making me go to the mall?"

We escort her to her room, the officers help her get her wet clothes off and give her medication, and she goes to sleep. And you come back and look in her room, and you see this woman who was just in a severe crisis and is there in a balled-up position with a blanket over her. What are we doing? What are we doing?

I'm still learning a lot of things about the severely mentally ill, but it's challenging. It's comical at times. It's dangerous a lot. They're real unpredictable. Everyone's on their toes.

You can't just take a mentally ill person and lock them away. Society has already shown it doesn't work. Why would we do it here? Not one of these people should be here.

Gerald Smith,
```
Cermak corrections officer
```

Working here you have to be comfortable in your own skin. You have to be comfortable being in uncomfortable situations. Patience is a virtue here.

It's a revolving door here; you'll see some of the same people numerous times. Some people we know by name, we know by face. A lot of these people who do take meds will have a moment where they feel fine, and they think they don't need them anymore, and when they stop taking them, they don't recognize their behavior, their demeanor, all of it regresses. And then by that point they're not in their right mind to go back to taking the meds properly.

We've had as many as 50 people up here on this unit, even though there's only 24 beds. So we have guys on mattresses on the floor. It's always full.

The majority of us who work up here have been attacked physically. They need more space here. There are more and more people coming in every day with mental illness.

Cermak Health Services provides healthcare to the Cook County Jail population.

Cicely Bailey,
supervisor, Treatment Alternatives for Safe Communities (TASC), Court and Probation Services, Cook County Jail

Typically, a lot of mental illness is undiagnosed. Sometimes, we are lucky enough to catch them and persuade them to get the mental health evaluation, and then stabilize them in every way that we can. But a lot of mental health problems they self-medicate with drugs.

They need mental health care facilities in place. Otherwise, everything is going to peak, as far as crime—recidivists, they're going to go back to jail—all those things are going to peak again because these people are going to be without care. I'm just scared. I'm scared. I don't know what's going to happen, but I foresee a lot of problems.

Have you heard the stories of those that do things to go back in jail, just to get the medication they need? That's the scary part, too. I just see the numbers rising in jail, or they're staying in there longer. Sometimes, we get an order from the judge that says "release to TASC only," which means they can't get out until we find a facility that will take them—and if you can't find a facility, one week goes by, two weeks go by, so the wait list is going to be long, and then that means they are going to stay in jail longer, which is unfair to the client. We can't find a place in the community to address their mental health needs, so they're staying in jail. It's sad.

The Tinley Park Mental Health Center, which once housed and treated over 2,000 people, was shuttered after Illinois cut $113.7 million in funding for mental health services between 2009 and 2012. The paucity of mental health care in the community has increased the number of people receiving mental health treatment in jail.

00 10 20 30 40

50 60 70 80 90

Serving Others from the heart.

Mental Ward
Is where I Landed.
Personal Life is being tested
relaxing with a "Camera" photography is a blessing.
Bipolar before you
Leave Can you please have
A Rose I am on a Roller Coaster ride with a flower to my nose
Mental Ward
Is where I Landed
Personal Life is with my flowers
I will sing to some of the plants
While the other plants take a "Shower"
Bipolar before you
Leave Can you please have
a fruit. I am on a rollercoaster ride Mental awareness on the Moon
Mental Ward
Is where I Landed.
Personal belief ~~~~~~ ~~~~~~ is being tested.
Correcting my short-coming
Asking my flowers for SubJection.
Mental ward for
being label Bipolar,
Praying for a change
A Rose and a Camera with a flower in my hand
Bipolar before you
Leave. Can you please have
A Rose. I am on a "rollercoaster ride"
Serving all of God's roses from my Spirit and Soul
Serving others from my heart.

A Mental Ward

Am i Crazy or Label Nuts?
A Jailcell once Again........
Am i° ᵖᵃᵘˢᵉ Ashame of My face
The ᵖᵃᵘˢᵉ Make up So i pretend.......

Sometime's° i come To Jail
Most time's I am Trapped in Prison........
Pretending to Be in Love
Am I Nuts i° keep Sinning......?

Sometime's° i come to prison
Most time I am Trapped in Jail.........
Insane with My Behavior
How the hell i° ᵖᵃᵘˢᵉ Became hell........

Am i° Nuts or Just Crazy?
Maybe Lazy Don't wanna Work.........
Label Nuts By My ᵖᵃᵘˢᵉ family Doctor
Bipolar -N- ᵖᵃᵘˢᵉ Depression ᵖᵃᵘˢᵉ Am i° Cursed......?

Sometime's° i° get Away
Most times° i° Get Caught........
Arrested And Depression
With Bi-polar Crazy ▓▓▓ Jokes......
Am i° Crazy or Just Nuts?
For playing ᵖᵃᵘˢᵉ Crazy Just to Win......
I Lossing My Mind for playing Crazy
With all My Mental Crazy ass friend's........

Letter by Marshun

Lance

I've been here almost 16 months and I'm part of a program called behavioral modification. We have ways to manage our anger, coping skills, education, your vocabulary, your respect, your ego, and we practice those things on a daily basis. When I first got here from Division Nine, we weren't even allowed to have women officers working there because it was an environment where there was masturbation toward females and throwing feces and acting out, just primate behavior. I used to get irritated all the time trying to stay out of trouble and trying to stay focused. I always felt uncomfortable because I wasn't raised like this.

One of the key things we work on is not just getting out of jail but staying out. And it's a lot of people that won't make it home, and for those that are going to prison they gotta keep the tools they learned here and try to be content instead of going to prison and losing your mind and becoming an angry or uncivilized person. Some of us are blessed to have great support financially, mentally, and spiritually, but there's people here that doesn't have anyone. We go into deep discussion, you know, about the importance of gangs . . . gangs are not a good thing, they're a bad thing—you destroy your community, you destroy other people, and you hurt your loved ones.

I'm from the South Side of Chicago, the Englewood area. My mom was a single parent. She struggled with alcohol abuse. We always had the key essentials: food, shelter, and clothes. Sometimes she would work two jobs, three jobs. I was fortunate enough to have family that is middle class, so on weekends I would spend time with them. I was always wondering why relatives that were living in a suburban area—not only was their education system better but they were way more advanced than we were. The more time I spent there, the more it brightened ideas for me about other things—a better life, the value of the dollar, the value of family—how not to be destructive.

There were times it was hard for us—there were times we had no lights, no gas, no water, and we learned to be content and still happy. My mom was a single mother and it came to a point where I didn't want her to struggle anymore so I turned to the streets: gangbanging, drug selling. I thought me giving her extra money would help, but you know the things that come with it—the shootings, the fighting, the sleepless nights—and on

top of that you're distributing a product that's hurting other people. It came to the point that I didn't want that life anymore. I'm looking at people and am like, "This is someone's mother and you're taking her last money that she could be paying the light bill with." And this is how we felt when we didn't have lights—someone else taking the money out of our household. So it came to a point where I wanted to move with family members that was middle class and start learning, not just how to value my life but other people's. I realized I wasn't helping my family, I was hurting.

My mom changed for the better; she went back to school, got her education, got a better job, better living, and she was able, as a single parent, to send my younger sister to college. It was then I still could help her, but she wasn't as worried, she wasn't like, "Where'd this money come from?" It wasn't dirty money. I was working two, three jobs to help her. It felt secure because it was the right thing to do—it was the right kind of income. So after that it came to a point where I just changed. But one thing that I didn't work on that I should have then is managing anger.

What am I angry about? It's more fear. I didn't have the best role models. You're either going to continue living like this, or die, or spend the rest of your life in prison, or you can work hard and have just as much if not more than they have. It was more of a fear of change. I was angry because of a little bit of envy. Because not everyone in my community was drug addicts or alcoholics—I had friends who had a loving mother and father and they were poor but they were happy. And they had a father when they came home to help them with their homework. They changed a tire with their father or painted the garage—things like that I didn't have. So I was always envious. I used to ask, why don't I have that? Where's my dad? I started thinking, maybe it's my fault that my dad isn't there.

Doing this interview with you guys—I'm still at peace. You guys get to go home and I go in there and shower and still be happy, like, wow. Because someone took time out of their day to come and take pictures, and bring a good time—talk to each other—it gives a lot of people hope, like maybe these people do really care.

This isn't my first time in jail; for a crime of this magnitude it is, but no, I've had a few stints in jail for minor, bone-headed decisions. Financially it's costly; mentally, emotionally it's costly. Sometimes it hurts—you're watching people, and sometimes it's the innocent people you see get sent away, and sometimes people that's guilty don't get sent away. Seeing those things can make you nervous—it's what make a lot of inmates in here spazz out. It's not that you don't know, it's more they feel like they don't have no one that cares—they're afraid.

Fear is a big thing we talk about here in our classes. Different kinds of fear. They're afraid because they don't know what's gonna happen—they're afraid that they're gonna lose the rest of their lives. So it's not my first time in jail, but it's the best time to realize that I don't have it under control. I pay all of my bills, I take care of my children, I be the best brother I can be to my siblings, the best son I can be to my mother—what am I doing wrong?

I got three kids: fourteen, nine, and ten. Two boys and a girl. My oldest son, I allow him to visit me here. Only him. Not my youngest son or my daughter. For one, they're too young to understand the lessons that I teach my oldest. He's 14 years old, a freshman in high school, and I let him come and visit me. I tell him all the time, I failed you—as far as, I'm here. The fact is, they're going to prove my innocence, but I'm here. And I see guys in here just a few years older than my son, 17, 18 years old with no families, their mothers have given up on them and their fathers are gone. I teach them all the time, if you're not careful with the choices you make and the friends you choose, you can be here. I see a lot of brothers here, and uncles and nephews—sometimes you see fathers and sons in here. I tell my son, "I don't want that for you." I don't want him to give up. All I've instilled in him and all of my experience of raising him—he might need me most now, he's a teenager. I always tell him, "Don't give up and stop the values that was instilled in you."

He said something to me that hurt my spirit: he said, "I don't want to go to college no more." I said, "Why?" And he said, "Because you're here and ain't nobody else going to pay for my college." It hurt. It hurt badly. I couldn't express the hurt in front of him—trying to be manly—but it felt like he's losing his shot at the dream because I'm here. So I had to tell him, hey, that's not an option. This time here just makes you appreciate what you have and how to value things.

Samantha

I have a son, he's four. This is my first time here. I really want it to be my last time. I've been here almost eight months. Every time I go to court it's continuance after continuance; they say they need to find more evidence so I don't have an exact date of when I'm going home.

My husband's family has our son. My husband can't even have him because he's in here with me, too. Same case as mine. Armed robbery. We still have a wild version of ourselves even though we're already parents. We decided to go with a group of friends, we were just driving around. We were on a lot of Xanax, acid, liquor, lots of weed, lots of coke. It was over three days. I was just dazing on and off and then I guess they ran out of money. My husband and his friends decided to go rob a gas station so they could pick up more drugs. I woke up somewhere in the suburbs by a police officer; he was telling me that he was arresting me. I didn't know what was going on.

I've been drinking since I was eight. The last two years, it's gotten to the point where I have to drink at least every other day; if not I can't do anything. I started experimenting with other drugs, taking narcotics, abusing it, taking ten at a time and washing it down with alcohol. I started using cocaine.

My parents are very religious. They go to church every Sunday. I felt like I didn't experience love as a child. I was 18 when I got married. I don't think I'm fit to be a good mom right now, or a good wife at all. I got married too young. Literally year after year after year my mother would have another baby and they pushed me aside and left me alone. I didn't have anybody. I barely saw my dad, he was always working. I used to go to my grandma's house and my other family members were there and they're all gang-affiliated. I saw guns all over the house, I saw fights all over the house, I've seen shootings. That neighborhood was really bad in the 90s, so I could never go outside unless I was with somebody.

On my mom's side, my grandfather died from alcohol. My aunt, she's an alcoholic and she also has mental . . . we all have bipolar in the family. I have another aunt who's been to prison and has been in and out of this jail multiple times; she's also an alcoholic. My uncle is an alcoholic, he drinks daily; both my aunt and uncle are facing the courts now because of their addictions. So my mom's whole side are alcoholics and they're gang-affiliated. My dad's side, they drink religiously as well. I remember them giving me alcohol when I was young, like six years old, just to try it. I've been diagnosed with bipolar back in 2012. It runs in the family; my mom, my brother has it, my aunts have it.

I was self-medicating with alcohol, definitely—every time I would have a manic episode. Once I was working in a CVS, and I literally stopped and realized I didn't want to be here anymore, and I ran home and convinced my husband—I don't know how I convinced him, me and my husband are both like not all the way there—I convinced him, "let's just go to New York, let's just take all of our savings and sell the car and just go to New York." And we did. I remember being in Times Square, it's really cold, it's February, and my husband's like, "Can we just find a hotel to go to sleep?" And I'm like, "No, don't you just want to sleep here in Times Square?" And I just couldn't go to sleep. It was just constant drinking, pills. It made my manic episodes more fun, but later when I'd have my depression episodes, that was the worst, because you literally could not get me out of bed.

I've been taking medication here. I feel a lot better. More stable, too. The therapy and the medication are definitely helping, but I still experience depression episodes and I feel them coming and I try not to dive too deep into it. The counselors and the therapists are great here. You can talk to them about everything.

I want to get my son back. It hurts me because both of his parents are in jail. I feel like I need to learn how to be a good mother and to get back on my feet. I miss him. I don't want him to come here because at the end of the day I have to say goodbye, and I can't deal with that.

Clarence

I'm from Chicago, Illinois. South Side, Englewood.

I got eleven brothers. My childhood was rough, I guess. In and out of foster homes, group homes, incarcerated a lot. A lot of reasons: first was because my mother had a gambling problem, and the other times was because of my insubordination, defiance. It was because I was growing up in foster homes away from my family. I was in too many foster homes to count. Six or seven group homes.

I've been here three times. I've been to prison, too, for different lengths of time. When I first got incarcerated I think I was like ten. It was for juveniles, a residential facility. I had problems, for fighting and stuff like that. I'm here this time for a drug case. I'm involved in gangs somewhat, but I don't like to gangbang. I'd like to get away from it someday. I've been around it my whole life. I've been around it so I get involved in it.

When I get out I want to get trained in something. Anything that's better than this.

When I was inpatient, I had some therapy, but it wasn't really nothing. I have bipolar disorder and conduct disorder . . . mental illness. I was diagnosed when I was eight or nine, the first time I went inpatient. I learned some coping skills—deep breathing, pleasant imagery, exercising, stuff I already do. It's helped me in a sense, but not really. I don't get my prescribed medication in here. Outside I take Seroquel, but in here they give me something else that don't do anything. It's hard for me to sleep and everything else that come with it. I've always had a hard time sleeping, that's one of the reasons I'm on the Seroquel on the outside. I use a lot of marijuana, too. It helps me stay out of trouble. It makes me too relaxed to want to go out and do something. I get into trouble when I run out of my medication or marijuana.

Up here it's hard to get access to my medication, because my mental health decisions were made down in Memphis, Tennessee. It's easier to get it down there than in Chicago because my mom's there and had all my paperwork, and my mental health place was down there. I had Tennessee care, but I ain't got no card or nothing.

When I get out I'm going to get my medication from the hospital, I guess. I don't know too many health clinics up here, I'm going to try to find some.

Dywane

I was born and raised in Chicago. I had it rough, I guess. The neighborhood I've been in. All the drugs. You can just be walking down the street and somebody's pack right there, and a cop can jump out and search you and everything and put that pack on you and you never even knew it was right there. Drugs right there, everywhere you step is drugs. There's a lot of violence. I've lost a lot of people to the street. It's because of money. I've never been involved in that. I got a lot of people who was, though. I had three people who weren't even in the streets that got killed for nothing. Wrong place at the wrong time. Mistaken identity. They killed my cousin, shot him in his head because he was a look-alike. He was just getting off work and was walking in his house. He worked his whole life since he was 16. Factory work for my uncle. Just working for a living. There's a lot of gangs around. That's where a lot of the violence comes from.

It's kind of my fault I missed my court date, but I had a substitute judge and he didn't give me all of my information; he told me that I should have called in to figure it out. But people forget that I have really bad ADHD and no one ever really taught me how to read, I had to teach myself. I chose not to go in the street like a lot of people, seeing people get killed every day.

I went to high school but I didn't graduate. I had a reading disability and the teachers made me try to read out loud in front of the class and I knew I'd get laughed at so I didn't want to do that. I can't read, I have slow comprehension when I read.

This is my very first time in here. It's terrible. We living in a mold-infested area, all in the bathrooms and in the bunks, and I got asthma and it's really bothering my asthma. The smell. I been here two and a half weeks. I'm only supposed to be here for a warrant but they kicked the door down to my daddy's house and they came in and found a lot of drugs. I didn't know they were in there because I was staying at my brother's. They basically put everything on me, a gun, drugs. And they laughed and they took money from me and my dad. They took $3,700 when they said they only took $1,900. They took money from my pocket. Never got it back or nothing. They put a lot of drugs on me and now I'm in here fighting that case for something I didn't do. Wrong place at the wrong time. I caught a case before but it only took one time for me to learn and that was over with. I'm 19. I never in my life want to come back here. They say I'm fighting 15 to 30.

This program been all right; they ain't really teaching me nothing. I go to make the day go by faster. They have been teaching me something, I guess, like coping skills and interview skills for a job, I guess. But that's pretty much it. It's important. When I get out I'm getting a job. Any kind of job. A factory job. I just don't want to get back in trouble—I just want to keep my hands busy working. Coming home, going to sleep, and then go back working. Stay focused. I don't even want to live in Chicago anymore. I've been here my whole life. I don't like anything here. My mom has a house out in Indiana but I can't even go out and live there because of my probation here. It's three years. The first time I went to court I didn't know nothing, they were saying a lot of stuff that I couldn't comprehend and whoever was supposed to be on my side was telling me to just cop out. Just cop out. We didn't do no talking or nothing. It wasn't fair. The only thing I did was smoke weed. I never drank, popped pills. I just smoked weed to get a lot of stuff off my mind. I be having a lot of thoughts. It calmed me down a lot. Memories about my people that got hurt, dead.

The police said I had a gun on my waistband and I threw it under the mattress when they came in. But I didn't even know there was a gun in the house. They found all these drugs, weed, cocaine, and they say I had all that at 19. I didn't know they had nothing—if I did I would have stayed out of there, I try to keep myself out of situations like that. I have a big brother who I look up to—he been working his whole life just like my cousin. I stay with him; I just decided to go over and visit my dad and this is what happened. My younger sister and brother are in Gary, Indiana, with my mom and I wanted to go with them but I can't because of this thing. I think about my mama every day. I don't really know anything about my parents' history. I was always told not to ask questions. Just listen.

I never in my life have been as dizzy as I am up in here. Every day, headaches, wooziness. I don't feel good. It's not just homesick. My head be hurting real bad. I hate Chicago, I want to get out of here so bad. I ain't never coming back here. For real. I don't get along with the guys in here. I just sit in a corner by myself.

Dr. Dena Williams,

director of behavioral health,
Mental Health Transition Center (MHTC),
Cook County Jail

We try to do as much as we can here; sometimes, the treatment that they receive here is more than they receive on the outside, because a lot of the clinics have been shut down. We try our very best to pull in as many resources as we can to try to connect them, and try to also partner with agencies once they get discharged. That's the key piece—once they get out, we want to make sure there is a continuity of care. So we really, really try our best to find those clinics that are still available and give them those resources to tap into once they leave.

There are not enough resources on the outside. We have people who are suffering from a mental illness who decompensate because they don't have access to medication, and law enforcement might not be trained with how to deal with it, so instead of sending them to the hospital, they get arrested and come to jail.

In an ideal world, money and more resources need to be put into more programs and treatment availability on the outside. There needs to be funding for mental health programs, and mental health treatment and access to medication.

Particularly in a city like Chicago, you do see a lot of individuals, both male and female, who come in who have experienced some sort of trauma just living in an underserved environment. If we can do something with the adolescents and the children, I think it would save a lot of people from coming here.

I think it's very, very important to start outreach to a younger crowd, so even going in a juvenile detention center, offering programs similar to this, would really, really help with the lack of resources some of these young girls and boys have. It would be essential for them to receive that help and receive that support, so hopefully they will make different choices and don't end up in our custody.

Velma Ball,

correctional rehabilitation worker,
Cook County Jail

There's a lack of help for mental illness in the world; there aren't as many mental health facilities for people to go to. We're probably mainly a mental institution now.

In here, we need more funding, more help with mental illness, more attention to inmates' medication and their psychiatric needs. I think in here they're medicated, but they're not dealt with adequately psychiatrically. We're not adequately staffed to accommodate the mental illnesses and types of mental illnesses that these people have.

To me, the mental illness in females is a lot worse than males . . . These people have kids, you know, it's just a domino effect. I think we as women, we are emotional beings, so we need support, and I don't think they get the support here that they probably need to maintain their medication, to become a mother, to hold down a job, to be an effective parent. I think when they become incarcerated they get crushed.

The abandoned Tinley Park Mental Health Center.

Andrew

I've been diagnosed with depression and anxiety disorders, so I take meds for those things. I was diagnosed many years ago, and I was looking for treatment, and I was having trouble finding it, so I was self-medicating with alcohol.

My sister is my only family member who has ever been supportive of me. I'm estranged from my father—he remarried after my mom died. I wrote him a letter when I got in here, telling him what had happened and where I was, and I never heard anything from him.

I got a letter from some Social Security people saying that they found out I was incarcerated, and they had stopped my payments, and I was responsible for paying them back for the four months that they had paid. So the first thing I have to do when I get out of here is go to the Social Security office and get that fixed.

I've heard different stories about whether mental health problems could be hereditary or in the bloodline or something like that, but I have no way of knowing because I'm adopted. So it could be in my biological history, but I'll never know.

I was getting medication from a place called the Ecker Center, but I couldn't get the medication that I wanted. They tried a few different meds on me, and they didn't work so I just gave up.

Jail is jail, but I'd rather be in this situation than in the general population. This is easier to cope with than being locked in a cell, so I'm grateful for that.

Tommy

This would be my 11th time in Cook County. Why am I here? They say because anxiety. So I take anxiety pills. They help—they help a lot. I used to be a lot more antsy . . . I think this was diagnosed when I first came in. I think, but I'm not even sure, you know? I wasn't even paying attention to what they were asking. I was just answering them, and I ended up here.

Our counselor has been very helpful. She's very professional, very attentive to every single one of us. From day one she tells us this is a family, and everybody gets treated as family. I thank God for her.

Growing up in Chicago, we go through a little phase, I would say, trying this, trying that. But I never really stuck to drugs. Alcohol, oh, that's everywhere, so I just had a little bad luck getting caught driving a little intoxicated . . .

This program . . . everybody's trying to go home, everybody's trying to work on their problems, their behaviors. They're giving you the help, so the last thing on everybody's mind is going back to your old behaviors.

I get real frustrated real quick, but now I know what the problem is. So when I get out of here I'm going to go to the doctor and continue my pills because it helps me a lot. I thank God that Cook County has this opportunity where we can take our pills.

Being in jail, the smallest thing would get me frustrated—like commissary wouldn't come on time. Other stupid things, like why is that officer screaming? I know it's her job, but little things, you know? Like, why can't I watch this TV show? But as you get older, you start to notice you can't have it your way, and this program here teaches us that. Before, I would break things, like a dummy, break things or scream out, lash out. And that would get me into trouble. But now, I'm OK. Thank God I got diagnosed.

This division of the jail, this is Hotel California right here—you can't get no sweeter than this. This is the best one here. Other parts of the jail, you got some people who think they can handle everything by pushing people around, so if you don't know anything about that you tend to get taken advantage of. A lot of people here, this is their first time in jail, and they think this is Cook County. It's not. I try to tell them, you think this is bad? Make this your last because this is nothing. This is the tip of the iceberg.

Daniel

I've probably spent three years of my life in jail. When I was 17, I did 18 months straight. I've been through the prison system a few times. I was in the youth homes when I was a kid—first time was when I was 13. So I've been through the system a little bit.

They got me on antidepressants. They got me on Prozac, so that got me over here. When I was a kid, when I was eleven or twelve, they put me in a psych thing. There was a lot of shit going on with my family. They thought I was depressed, so they put me on psych meds, and I've been off and on that for years.

I would like to stay clean. I think I have a good shot. I want to stay clean. I think I can do that.

If you're in a regular tier, especially in county, there would be a lot of gangbanging and shit like that. It's not like that here. There are a lot of young kids over here, but at least I'm away from the noise and the gangbanging. It's my first time being in treatment in jail like this. It's different. It's better than being in a cell because you can move around a little bit.

A lot of people in the treatment are addicts. A lot of people in the jail population are, too, but they're not copping to it. There's a lot of drug addicts where I'm at.

I'd like to get out of Illinois when I finish my probation. I've just been in trouble here for so long. I think it's time to go. *(Pictured on following page.)*

Condition's to be Ashame......

Tell me
what's the use of caring?
when no one care's enough

what's the use of sharing?
when the Government eat's it up.....

My braincells over aleat
my inner plight *pause* lost in worries.....
my love for Jesus Christ
keeps me from dying in a hurry....

Welfare nightmare......
food stamp's when i dream
handcuff's because i am poor......
plus it burns when i pee

Am i wrong to want it all?.....
Change my thought *pause* but still the same
praying for heaven door's
wondering is heaven a prison cage......

Faith or fate determination court system owning me.....
it pay's to commit crime's repeated killing's in the street
what the hell is going on? *pause* Equal right's seldom seen
proper manner's when i speak some people still treat me mean...

Am i wrong to want it all........
A poor person why bother
A slave ship brought me here America
while many slave's try their best to take me under...

What are you saying???

Bi polar who would have knew that? I would somehow get married...

Bi polar looked very fine until Bi polar became scary......

Bi polar mood swing's "ABNORMAL" different stokes
Bi polar meltdown Negro spirit -n- African folks......

Bi polar you look different "from" your sound on the phone......
Bi polar nice in the public eye Yet very violent in the home......

Bi polar I did't mean too hit you I am "Sorry" once Again
Bi polar I choose you over my family -n- my friend's......

Bi polar whom are YOU upset with? I give you all my money
Bi polar is you jealous? Because "we both behave naughty......

Bi polar you crashed my car and I can't get to work
ABNORMAL road rage some one Died when you drove......

Bi polar prison cell asking every one what the hell happen?
Reality "courtroom" prison time mine only option......

Bi polar whom do you call? When no-one understand's
Bi polar little child or Bi polar older male......

Bi polar whom do you tell? When no-one wanna hear it
Bi polar teenager's or Bi polar older women......

Bi polar "Stay away -n- Stay sober next time
Bi polar stay focus -n- Stay away from your mind......

Letter by Marshun

Milton

I'm from Dallas County, Alabama, but I was born and raised here in Chicago, on the South Side. I stay in trouble—been in trouble since I was young, you know, pretty much led me here.

When I got here, the psych nurse had me come down and talk to her, asking me what's been troubling me, what's been troubling me all my life. She gave me a med, I don't know what it was, but it kind of brought me down. Being in that program down there, oh, it's an experience. It's an experience.

I've been in jail quite a few times, all right. I've watched this place change. It used to be like, back in the days when you come in here, you had to fight your way through this place. Either the officers will beat you up or you fighting the gangs. If you're not in a gang, that's bad for you.

I don't even know how many times I've been to jail. Can't remember my disabilities . . . The lawyer asked me that, and I said, "I don't know, I really don't know." It's been so many times. After high school, it went downhill. I signed up for the Marine Corps, didn't make it through that, and it's been . . . downhill. I mean hard as I try, just downhill.

Our parents got sick, and they died at an early age—both of them, they died like a month apart. I remember it like it was yesterday. I couldn't have been no more than five or six. We were at the grocery down the road. We lived out in the country down in Alabama, way out in the woods, and we came back home, and my mama had her eyes open. She was laying there with her eyes open. My dad couldn't take it. I guess he just . . . One morning, we had to go to school, and he had threw up everywhere—took him to the hospital and he was gone. We didn't see him no more. First thing came to my mind was, what's going to happen to us?

My oldest sister brought us here to Chicago, but the brothers and sisters who stayed down there are more prosperous than the ones who came here. Just me and my baby brother came here, and my sister came here . . . and she was killed. Her husband shot her. I came in, went to my sister's house . . . seeing her, there was still blood on the floor.

But you know, you learn to deal with these things, all these heartaches. I'll be better when I get out of here, though. This is a dead house . . . It's like a death trap for me. I got to get out of here.

I know I'm messed up! I've been doing the same thing for a long time, you know. It's hard to stop. I've had a psych evaluation before; when I was young, I stabbed a girl in the head with a pen. They asked me why I did that, and I said she tried to push me off a balcony. It's a mad thing. You can be crazy and still function properly and yet you're crazy. I don't get it.

I'm on medication here, but I don't know exactly what it is. I'm not a bad person, but if you keep pushing me . . . you can't go in the woods and keep pushing an animal, you know.

You got these jails, and you can't do nothing, can't control nobody. If they start helping the community more, put more useful things in, neighborhood things, it might be different, change. You don't have basketball courts in the neighborhood no more, you don't have help keeping them up. Instead of the guns and the policing—you could put a baseball diamond up, teach them on their baseball field.

As soon as I get out, I want to get me something to drink, and I'll probably go by the store around my house and get me a nice small steak and take it home and beat it up, sit down, eat it, take a hot bath, and lay back. Get the crazies off my mind.

Nikia

My childhood was good. Nothing bad happened that I can recall. My mom, she works at a factory somewhere. My dad, I don't know where he at, he in Michigan somewhere. My mom got my kids. I have five. I got a little baby, eight months. I came here when she was three and a half months. It's hard because I haven't seen her since. And I want to see her. I just hope she'll still remember me. My bail was denied. They gave me a "no bond" because I had a warrant. I'm just trying to get myself together so when I go home I won't have to worry about this place ever, ever. I ain't never been in jail, this is my first time.

I had to go to treatment because I'm in for a DUI. I had gotten into an accident. Didn't nobody get hurt; I hit another car and I didn't go to court, so I came here. I can't wait to go home. I don't do jail. I ain't ever doing nothing else to get in here. I'm in this treatment program for drinking. I want to get this over with. I've been drinking for a while. I started drinking for real at seventeen and ever since—I'm twenty-nine now. It just kept progressing, getting worse and worse with the drinking. I don't know why I started, but when I do drink it's because I'm upset. I don't even know what drives me to that point. Sometimes I do it just because I want to do it. At home I used to be sneaking drinking. It wasn't like I couldn't function; everything was OK. I would want to drive and that's illegal. And that's crazy.

I never thought I'd see this day where I'd be in jail. I've never been in trouble before. I'm gonna show them how to stay out of jail because I am not coming back. I've already seen people who have been back two and three times. Not me. I'm going to have to work on that because it's easier said than done, but I've got a lot of goals, a lot of plans to keep me out of here. I'm going to outpatient, I'm going to meetings, something to keep me busy so I won't be thinking about drinking. Keeping a schedule with my kids and school and stuff. I don't want to drink, I don't want to have to depend on drinking for me to be able to do stuff.

I want to be better for my kids. Even though I'm not knowing how they're feeling, because when I talk to them they're happy to talk to me, but I know they're feeling some type of way. We have contact visits on Saturdays so they happy when they see me, but when it's time to go they cry. I be telling them to talk to me and tell me how they feel, and they just tell me they want me to come home. Nobody is going to treat your kids like you. I'm they mama. They going through some stuff because everything different. Because when they talk to me, they tell me about a lot of stuff that's going on that would not be going on if I was home. They're getting in trouble at school, fighting, stuff like that. That's started since I've been here.

I wasn't working before I came here. I was in the house most of the time because my baby's sick. She's got a heart condition. She takes two types of medicine and I wasn't ready to let nobody else watch her. I got to get myself in this treatment program and get myself straight first, then I'll start looking for a job. This program here at the jail has helped me. I've been interested. Especially when AA come—hearing other people's stories—I be listening, too, because that's how they start off—with the one thing, then they go to the next. I just been drinking. I'm glad, too, because I would have been all messed up.

I'm not sure what I want to do when I get out. A long time ago I wanted to be a lawyer, but then all this stuff started happening. I started having kids at an early age and it just went everywhere. I was fifteen when I had my first baby. I do hair, I support myself with that. And when I was pregnant I was working at a temp agency. My family helps me out. I don't know what I'd do without them. My kids get what they need and sometimes a little bit more. DHS [Department of Human Services], too, they help families who have issues with cash. They give you cash for the kids for a time. And I get SNAP [Supplemental Nutrition Assistance Program], too, that was very helpful.

In five years, I want to be in my own apartment with my kids, me working, being financially stable. And no alcohol, no ma'am. With the help of the people they got here, I'm going to be reaching out. I'm going to help myself for my kids. It could have been worse—a lot of people in here don't have custody of their kids and I be hearing their stories and I be crying because I don't know what I'd do. I'm about to cry.

Patrice

I'm from the South Side of Chicago. I've lived there all my life with my mom. Currently I don't have a place to stay. When I get out, I'm mandated to a treatment center. My childhood was a struggle but I deal with it. I had problems growing up. My mom tried to get me the best help that she could. It's six of us. I had educational issues, I needed a little more push than others. I graduated high school and I did two semesters of culinary arts.

This is not my first time in jail. I've been here quite a few times. Wow, I've been here so many times. At least 12. The first time I was here I was 18. At that time, me and my baby daddy was together; he bonded me out so I didn't make it upstairs. But now I'm on my own and I don't really mess with men anymore. I have two kids, a seven-year-old and a six-year-old. It's not hard being here with the kids because my mother has 13 grandchildren. My family would all want to go outside and I'd be the babysitter, so they'd call me and tell me, Patrice, we give you this amount of money if you stay home with the kids today. And knowing me, they give me this money and the weekend come around again I ain't babysitting your kids again this time because I got money, I'm going outside, too.

I'm here for residential burglary and escape from house arrest. I've been in and out of this program. It's a struggle, but I am getting through this program this time around. Not to come back to jail is the main thing, but I'm getting to know myself more. I'm getting to know patience. It's helping me take responsibility for my actions. I got into this lifestyle because of me being greedy, me wanting gratification—like you put something in the microwave, you warm it up real fast, that's what I want. I want something that's right there and I know in life you cannot have something that's right there; I have to take my time. It's a process because of me having ADHD and wanting things to go when I want them to go, so it's a slow process of me trying to train myself to calm down and take time.

I don't get medication for my ADHD here but I'm getting medication for other things; I don't want to go into detail about that. This time around I am really getting something out of this program. Before, I was saying this program is full of crap—I would have just signed myself out. But this time I actually want to stick to it and make sure I get my 90 days. And I can prove to myself that I can do something with myself. Society says that the younger generation, the 90s generation, are messed up anyways, but if I can prove to myself that I can sit down and actually do this, then that's good.

My goal is to be a better mother to my kids. I got a lot of goals. I probably should get divorced. I got to worry about myself and get my things together, and go to a counselor and really sit down with my problems. I want to be a chef—I love to cook. I love the medical field, too, but with a felony I can't do that.

Need Help When You Leave?

(773) 273-9433

TELEPHONE CALL MAY BE
MONITORED AND RECORDED.
YOUR USE
TELEPHON
CONSENT
MONITORI

TO REPORT LIVING UNIT
PROBLEMS CALL
773-916-6280

PRESS 1 FOR ENGLISH
PRESS 1 FOR COLLECT CALL
THIS IS A FREE CALL

Excuse me Miss
I would like to Let you know I care.
Excuse me Sir
I would like to let you know I will always be here.
Chicagoland is where I Live.
Chicagoland is where I stand.
If I believe in myself then
anyone can.
Excuse me Little ant.
Excuse me Little Fish.
Excuse me president
Excuse me Little people.
Chicagoland is my home.
Chicagoland is my friend.
Chicagoland is my Spirit.
Why the violence in this freedom land?
Excuse me Little pigs.
Excuse me Little wolf.
Excuse me Citizens
Excuse me Little Crooks.
Excuse me little frogs
Excuse me Little dogs.
Excuse me Little trees.
Excuse me Little Logs.
Excuse me policemen
Excuse me School teachers.
Excuse me ~~politicians~~ politicians
Excuse me gifted students
please help me Stop the Violence

Theresa

I have 15 kids; I only have 10 living, though. I'm here because of my actions being on drugs. I'm the oldest out of 12 of my siblings. I also have a DCFS [Department of Children and Family Services] case—I'm fighting to get my ten-year-old son back into my custody. I hit rock bottom. My drug addiction was so bad it took a big grip of my life. It's not my first time being locked up, but it's my first time really understanding the triggers of my addiction.

I first came here in '93. I went to jail, I went to penitentiary. I was pregnant then. God saved me so my baby wouldn't be born with narcotics in their system. I recovered and did a year interning, and they hired me and I worked for three years. Got in a big old relationship, sent me back out—I wound up going back out onto the streets. I lost everything. I lost my house, my clothes. The drugs, it's a rapture, it really takes a big hold. That type of drug I was doing—crack cocaine—it's a big spirit. I found myself doing things that I said I would never do, but I wound up prostituting myself. Thank God that I didn't lose my life.

I've never been an intravenous user but I've seen so much of it and that's the reason I would never do it—because they cry so much when they can't find that vein. The drugs put a behavior in me; I was like, "I got to get that money—if I don't, what do I do for it?" So I start stealing out of stores—I was just in this madness. I was out there pretending I was a lion just roaring on this earth. And my three things was to kill, steal, and destroy. And that's what I did to myself, kill all my spirits and destroyed myself, my self-esteem.

I'm here, I got a good judge, I'm taking parenting classes, and I'm learning about me. My family loves me. This goes way back—my grandmother left my mom when she was only three months. My mom did that to her daughter. My mother has done a lot of things in the past that I never thought a mother would do. I'm thinking, I'm not going to do that to my kids. And then I kind of found out that I'm in that cycle again. She left hers, I left them. That's a cycle I don't want to continue to get wrapped up in. I'm fighting for my life and I'm glad that I'm in here.

I want to spread to the world that you can always have a second chance. Keep the power, keep the faith, and know that it's going to be a better day. Because some of us do not return. Some of us go six feet under. I grew up in a dysfunctional home. My auntie adopted us. I've always had high self-esteem, but when you do those drugs you think you're Miss America—you think every man want you. I went from 280 down to 90 pounds and a man told me, "You ever looked in the mirror?" And I said, "I look in the mirror all the time." And he said, "But have you looked at your whole self in the mirror?" So I went to look in the mirror and I saw nobody. I didn't even see me and that's scary. I'm fading away, my spirits is gone. I'm the walking dead. I refuse to be the walking dead. I refuse for the devil to take my soul.

Since I lost my house, I'm going to go to a safe haven for now. But I'm going to find a job—there's resources here that help you find companies that will hire ex-offenders. I'm gonna build my money up and I'm gonna go to an SRO [single room occupancy], and go to lots of meetings. I'm not going to take big steps and trip over them, I'm just going to take one step at a time. My family, what they did to me was wrong—they called the DCFS on me. But let's say I want to cook a nice dinner and invite everybody over, we're going to have roast, and macaroni and cheese, and greens. I'm going to have three different pitchers of Kool-Aid slushy. I just want to tell them that I appreciate them so much for still believing in me when I could not believe in myself.

My mom was a hardworking mom. I stayed home and raised my brothers. I got a brother that's deceased, I got a brother who was shot and he's paralyzed for the rest of his life. They should have just killed my brother. That's how he feels; he's suffering. I remember baking cakes and cookies with my mom, posters on the wall, up-to-date, new outfits. But somewhere down the line things turned and I didn't understand why. I saw my mom get beat up a lot. My husband hit me one or two times and I said, "Oh, no." I think my mom did probably all she could do. I started using drugs at the age of 22. I went down an alley where all the rats and garbage is at and I didn't come out until I was 36. I didn't start going to school until I was 11 years old because I was babysitting my brothers; that's why I want to go back to school. I dropped out of school at 16, had my son at 17. Now I'm damn near half-a-century, but I think there's still some brain cells up there. I'm determined to get my high school diploma or my GED. I'm proud of myself.

2209-1

2205-3

2205-2

#41
2205-3

2227-1

WHAT ARE

- What happens I will choose to be happy — Trina
- I have love and gratitude for my Life
- I'm ready for Our Happiness — Johnson
- I choose to be exactly who I am! *Trina C.*
- I am grateful for everything I have
- There is no good which is out of reach — Peaches

I can be happy even if the people around me are not
-dhantera

HE

My Dreams Are Coming

FUCK
THE
POLICE

"Head"
ND
bbyCAKesz

JZ

A

(A²ˣ)

Russell

I'm from Chicago, been here all my life. My mom, she's a single mother; she takes care of the three of us. I've got one brother, one sister. Never met my dad. I haven't talked to them since I've been here. My mom, we haven't been very close lately, you know? I know it's hard on her, me being here. I start trial next month, though . . . I've been here for three years. This is my third time in jail. My first time was like six months and my second time was maybe five. I'm looking forward to it being over, to change my life. First I got to start by changing my environment, you know?

Being in this program has helped me a lot, especially the second-chance program and the Christian program. At first I didn't really believe in God, but

now it kind of helps. The second-chance program helped me to become more of a mature man. I used to be childish, I used to have childish ways, and it made me really think, you know? Think about life and just want to do better, because there's a lot more things out there than the stuff I used to do—because I've been gangbanging all my life, and this actually really helped bring me out of that stage.

I started in the gang when I was 12 years old and I'm 27 now, about to be 28 next week. I was living in a gang neighborhood and I just started hanging around with the wrong people, and I just got caught up in the lifestyle. The reason I'm in here has always been gang-related, that's how it all started. When I get out of here I was thinking about moving, because right now it's really messed up all around the city, you know? I don't need to get caught up with that, so the best thing is, I leave.

First thing I'm going to do is call Tom and Wendy, that's the Christian program—they said to call whenever you get out, they'll have something set up for you. I haven't even thought of, like, a dream job; I've been too focused on freedom. I can be strong enough to just say no way, I don't want anything to do with you guys anymore, but even if I go in the same area—even though you don't want to be a part of that no more, there's still people from the other side who still think that you're a part of it, and then next thing you know . . .

As soon as I was coming up and got caught up in the lifestyle, my mom moved my sister and my brother away. I got moved, too, but I came back. Getting in the gang, I had to take a two-minute beating. I was really young. I was 12. At first it felt . . . it's weird to say, it felt good, like I was a part of something. I wasn't getting . . . I don't mean to sound soft or anything, but I wasn't really getting the love I was trying to seek at home. I found it in the streets. Plus not having a father figure, I took some of the older guys as my father, my older brothers. I was committing crimes ever since I joined in, right away. You got to prove yourself, that you're worth it, or you're going to get beat again. At first my mom didn't know, but then I was getting in trouble at school, I was getting caught with pistols. She kind of knew I was into that mess in the streets. She tried to be there for me, but I was in that phase that she wasn't accepting me for who I am. She tried to pull me out, moved me away, took me to California, took me to the Philippines. She moved here from the Philippines when she was young, 16, and she was already pregnant with me. She was working two jobs to support us . . . she didn't speak that good English. There's guys from the gangs in here but I'm trying to stay away from all that.

Nicole

I've been here for 13 months. It's my first time here and my last. I have four armed robberies. I've been on house arrest before, I've been on probation before; this is my first time doing actual time. I was brought up with a good family. They were very caring, but they had a lot of secrets, too.

I was the center of attention for six or seven years until my brother came along, and then that kind of threw my whole world upside down. I started drinking when I was 11. I was bringing bottles of alcohol to school. When I was 13 I was molested. From 14 on, it's just been downhill after that. He wasn't charged; he was a family member so they just kind of pushed it under the rug. I told my parents.

I'm 30. Today's my birthday. I have a son who's 11. He came to see me for a contact visit and that was his first time seeing me in months. He broke down and cried and was telling my mom how much he misses me. I know he misses me.

He's staying with his father. We just got divorced. It's a lot of stuff that happened all at once. This program has been amazing. It's been really good. I've made some really big strides in my recovery here. I have forgiven my cousin who molested me. I am working on my childhood trauma now. This is helping me get my sentence lowered. This is helping me be more trustworthy with my parents and have a better relationship with them.

It started with alcohol and then I was smoking pot. Then I started cocaine, and then I was doing heroin, and then I was doing heroin and cocaine. I've been clean from heroin for two and a half years now, and I was totally clean for nine months until I had this relapse and then got locked up for it. I've been diagnosed with ADD, bipolar, depression, anxiety disorder, borderline personality disorder, impulse control disorder. The medication here is not nearly as good as the medication on the outside. They put me on Thorazine in here, which is an antipsychotic, and since I've been on that it's helped a lot. It helps with my anxiety.

When I get out, I am going to be helping one of the facilitators here with her "ladies in orange" program—it's a non-profit to help women who have been imprisoned to get out and have resources. I'm going to go back to school for technology. I'm going to be doing my counseling. I'm going to work on getting custody of my son back and work on rebuilding relationships with my family that I've lost.

It's not just drug treatment in here. It's life treatment.

Kelsey

I'm from Englewood. My childhood was kind of rough. I grew up in a drug-infested neighborhood with a lot of violence. My moms and my dad separated shortly after my baby sister was born. My childhood became rougher when I became part of a gang. I started doing things that normal kids don't participate in, like selling drugs. I got violent and that caused me to come in and out of this situation. I went to a doctor when I was 13—a sight doctor—and he diagnosed me with being depressed and bipolar. But I never wanted to go see no doctor because I thought I was normal and that resulted in me coming in and out of here. I self-medicated. I didn't want their medication because one of my cousins was on medication for his mental illness and he was like a zombie.

I medicated myself using drugs. Alcohol, marijuana, wack—that's PCP—I used to smoke that real heavy and that used to make me feel right; in reality I wasn't OK, I was more crazier than I was. I joined the gang when I was 13; I saw these guys as together, there was unity, they loved each other, they did things together like family, and I wasn't getting that from home. It felt like family because I felt accepted. My mom when I was growing up always used to tell me that she hated me and that I wasn't going to be nothing and I messed up her life. I was her firstborn, she had me when she was 15. By the time I joined the gang I had no feelings.

I refused to allow myself to get close to anybody or share any type of emotion other than being angry. It took a toll on me. Me and my moms, we just really started now to get along. I accept the fact that she had me as a child and she really didn't know how to take care of a child. I was very, very angry at her and I was trying to figure out why she took out all of her anger and frustrations on me when I didn't even ask to be here. She could have had an abortion, she could have gave me up for adoption, she could have just thrown me in the garbage but she kept me and I have to honor that she did the best she could. I love her unconditionally. It made me who I am. The real me, not the person that's coming back and forth in here. The person that's aggressive, super aggressive all the time. That aggression came from her. She did a lot of horrible things to me. I vowed to never let anyone else do anything to me.

I've been receiving medication since I've been in here. My medicine keeps me level, mellow. I refuse to self-medicate. I'm learning how to speak about my feelings now. I used to just stifle it. It made me a ticking time bomb. And I really believe in this program I'm in now, I'm able to see the light at the end of the tunnel.

I been locked up six different times. I never invested in myself. I never knew that the core beliefs I grew up on were bogus. I used to think it was cool for me to be angry. I learned putting myself in situations that caused me to be incarcerated—I was being selfish. I didn't think about the people's lives that I was affecting. My family. I didn't know that it was alright to express love and compassion to other people. I vowed to speak up against that, upon being released from this situation. I'm going to advocate for us people who suffer from mental illnesses. I don't want anyone else going down the same path I chose: to self-medicate, not go to the doctor or therapist to talk about issues. I don't want nobody else to go through that. That's an ugly path and it was very destructive to me because I continued to make bad decision after bad decision because my thinking was always impaired with having a mental illness. That's just destruction.

My charges now are possession with intent to deliver. But I'm done. I'm going to stand up for what I believe in. Being productive, being positive, being mentors to the younger generation that's out there doing things in a negative manner. Guys like me, and having the proper resources, can break the cycle of young kids joining gangs and coming here. It's easy for me to say stop doing this, stop selling drugs, but if I take that away from them, what do I have to offer to replace it? Work, family, making money, community. A lot of these guys out there have different talents. If I don't have anything to offer them where they can use they talents and be productive, they going to say forget me, and keep doing the same things that they been doing. We need something else to offer them so they can see the light at the end of the tunnel. That's what we need, the resources, the money from within the community. These kids are being taught the wrong way—they ain't being told that if they go shoot a dude, you're going to be facing 30, 40, 50 years, 100 percent. They ain't being told that. So when I get out of here I'm going to put it wherever I can on social media; I'm going to tell the truth. The cat got to come out the bag. This ain't what you want. This ain't what you looking for.

Demetris

I'm 49 years old. I have been through a lot in my life, but I suppressed it so much that I didn't let nobody know that I have been sexually molested and abandoned. It wasn't my mother's fault; she was the same way. My uncles used to say that incest was the best sex. My mother was mentally challenged. She tried to keep me but she couldn't. My family kept my sister and brother and put me in a foster home. They put me in a good one but they kept switching me back and forth, so I would go to other foster homes and they would just have me for the money. Some of the men would try to go on me, but I'd kick them and I'd run away and then they'd stick me in the basement and feed me whatever they wanted to give me. Some type of way I knew I'd always escape. I called my mother and they called my caseworker and they came and bring me back to her house.

As I got older, I started rebelling. Because, talking to my psychiatrist—I used to go to a psychiatrist when I was younger because I was all messed up—I didn't know nothing about love, nothing, until I was eight years old. It's sad . . . I always knew how to love. It was always something I just felt like I was missing. I never knew my father, I never heard anyone in my family talk about him, so that's a big hole. I have an older brother; I haven't seen him in ten years. I have a younger sister; I see her off and on. Because of my addiction, I get away from my family because I don't want to hurt them. I did hurt them at first, I was stealing from them. I gave my kids up to their father because I didn't want them to get hurt like I was. But I forgot about abandonment issues. They were always with someone who gave them love, but I wasn't there. So that's another issue when I get out of here that I have to address.

I have to break the cycle. Of me moving and not being there for my loved ones. I haven't talked to my kids since I've been here. Alcohol is my real drug of choice. I hustled, that's how I paid for drugs and alcohol. I sold cigarettes. Prostitution. My real family I didn't know. They hurt me because they didn't want me, so I stayed away. I'm not ashamed anymore, either, because I found out it's not my fault because I couldn't control it. The only thing I can do is control me now. Even when I was five or six years old I already knew about the hurt. Otherwise I wouldn't have been able to fight those people off of me. I ain't dead yet. I survived what I went through, I can survive this. I'm a survivor.

I have been arrested 42 times. I committed suicide three times. I never told nobody I abused myself. I had a boyfriend who just beat me. He was an older man. I really liked him. I tried to swallow a bottle of pills, but I guess they ain't the right ones. I'm thankful for that. I'm going to have to stay out of my neighborhood. People, places, and things are triggers. Money is a real big trigger. I messed up too much of my life on the negativity. I take a pill for my depression and to help me sleep. I'm trying to get out of the depression because it's taking me back to my childhood. I'm glad I'm not having any more nightmares. I get in my own head before I go to sleep and being in my own head ain't good.

My dream is having my own place somewhere with my grandkids. Being happy with my family. With a dog in the yard, barbecuing. Working, just being a grandma. I can feel again, I can smell, I can taste, I can walk away. I like to laugh. I try to find the best side of everything.

TO REPORT LIVING UNIT
PROBLEMS CALL
773-916-6280

PRES FOR ENGLISH
PRE OR COLLECT CALL
TH FREE CALL

Renard

I was raised up pretty well but as I got up into my teenage years, I got involved with gangs, got involved with the drugs. I started coming back and forth to jail at an early age and that went on for over 20-some years. That was the life that I liked, and then before I knew it my kids starting going to jail and that really hurt.

I always maintained a job, I was always providing for my family. My drug use, I kept that hidden from my family for over 30 years. I've experienced verbal abuse, physical abuse, I was molested when I was a young kid. I didn't let anyone in the family know about it until I noticed I was having bad dreams and having all these old angry feelings and acting out. I let my family know that it was a family member—a couple of family members did some things to me and my mother and father took care of that, called the police, did everything right.

After that I never would have thought that years later, those old feelings would come back. And while I was

here I ended up getting into this program and got a chance to open up and let a whole lot of things out that I'd been holding on to. I stood this last time, I fought my case, I ended up getting probation instead of ten years. The judge that I got—he was like, "When do you want to start breaking this cycle?" And I said, "I already started breaking this cycle." I ended up telling the judge about the MHTC program, I told him about the counselors here, and he said, "I could tell there was something different about you, you didn't act like other inmates, you wasn't angry, you always had a smile on your face." From there I felt like I was rich. I felt enlightened. When I got over to this side [MHTC], I was free.

I was estranged from my children for a while while I was locked up here, but then we started communicating; things are still a little rocky, but they're a lot better now. Me and my oldest son are talking again—he has a son, he named him after me. I feel marvelous and I have to say, I started learning how to love my own self. What I learned here was how to give out: I do volunteer work with drug addicts, ex-offenders, alcoholics. I do volunteer work at a few shelters. It makes me feel good.

When I started job hunting, I had a few doors that were closed in my face, or the "we'll call you back" or "we'll give you a second interview." One particular place I kept going to, and the guy was like, "You've been here over ten times already." And I said, "Well, I know this job here is for me—there is one thing I enjoy doing, I got over 37 years of janitorial experience, and I'm not giving up." And I got it. I work for the Megabus company, cleaning the buses. Each time I clean something it feels like I'm creating something new.

Coming to the county jail—I've been here a good 25 times. First time I started coming I was between 13 and 15 years old. The majority of cases I had was drug cases. I used drugs to cover up a lot of things I experienced, hurt and pain.

I was diagnosed with mental health issues for the second time in jail. I tried to commit suicide about three times. I'm dealing with depression and anxiety, insomnia. Being treated with respect here made a very big difference. This program helped a lot of us to bounce back on our feet. I was able to start talking to the doctors here and start getting medication, seeing a psychiatrist. Can you just imagine coming here and being treated the way a man is supposed to be treated? With respect and consideration? And I was like, man, I am somebody. It made such a difference to me that I always introduce myself as Mr. Leaks, because I want to distinguish myself from the rest of my family members and everyone else. When we would have the NA and AA meetings, I was like no, I'm not who I used to be before, I'm not a criminal, I'm not an ex-offender—I am a grown man. I'm a father and I'm a grandfather. I'm Mr. Leaks and heavy on the "Mr."

```
Thank you to:
```

Andrew	Maximilian Lindner
Cicely Bailey	Milton
Velma Ball	Leila Needham
Roy Beeson	Nicole
Bicephaly Pictures	Nikia
Bonnie Briant	Patrice
Candace Bridgewater	Elli Petacque Montgomery
Emily Burke	Karl Peterson
Nicholas Calcott	Robert Phelps
Ravneel Chand	powerHouse Books
Kathleen Ching	Samuel Randall
CJ	Jonno Rattman
Clarence	Jan Reeder
Mary Crowley	Jenn Reeder
Janet De La Torre	Robert Reeder
Daniel	Russell
Demetris	Renard
Danlly Domingo	Samantha
Dywane	Caleb Savage
Eddie	Suzanne Shaheen
Sara Feinstein	Adam Sheffer
Michael Glier	Joan Simon
Nancy Glier	Gerald Smith
Jenny Holzer	Brendan Spiegel
Janay	Joanna Sullivan
Printiss Jones	Theresa
Sangsuk Kang	Tommy
Kelsey	Michael Tumminia
Maxine Keyes	The Vera Institute of Justice
Maciek Kobielski	Sarah Warshaw
Collin LaFleche	Colin Wilkinson
Lance	Dr. Dena Williams
Catherine Ledner	Zack Winokur
Marshun	Walter Wlodarczyk

```
I Refuse for the Devil to Take My Soul:
Inside Cook County Jail
```

Photographs and text © 2018 Lili Kobielski

Introduction © 2018 Mary Crowley

All rights reserved. No part of this book may be reproduced in any
manner in any media, or transmitted by any means whatsoever, electronic
or mechanical (including photocopy, film or video recording,
Internet posting, or any other information storage and retrieval system),
without the prior written permission of the publisher.

pH powerHouse Books

Published in the United States by powerHouse Books,
a division of powerHouse Cultural Entertainment, Inc.
32 Adams Street, Brooklyn, NY 11201-1021
e-mail: info@powerHouseBooks.com
website: www.powerHouseBooks.com

First edition, 2018

Library of Congress Control Number: 2018945211

ISBN 978-1-57687-888-0

Printing and binding by Midas Printing International Limited

Designed by Bonnie Briant Design, NYC

10 9 8 7 6 5 4 3 2 1

Printed and bound in China